"They are priests and the spo
daughters, they are pastoral le.
and fellow pilgrims sharing their struggles and doubts. And the
stories my sisters share in these pages are poignant, inspiring,
moving, and, above all, real. Come spend some time with Kelly,
Mary, Samantha, and Melissa. Whoever you are and wherever you
are on your own journey as a beloved child of God, you will count
yourself blessed to be in their company."

—Michael B. Curry, presiding bishop of The Episcopal Church

"Clergy are trained to hone listening ears and hearts as they tend
to the people in their care, and it is rare to glimpse the sometimes
intimate and interior moments of grace in their spiritual lives.
Grace in the Rearview Mirror offers exactly that. To the very end,
this book reminded me that looking back to see God's grace at
work helps me to step boldly into the future with the assurance
that God will be there."

—Jennifer Baskerville-Burrows, bishop of the Episcopal
Diocese of Indianapolis

"*Grace in the Rear View Mirror* is steeped in Scripture and theolo-
gy from four seasoned priests while evoking sensory experiences
of everyday life and death, plus a generous helping of humor. I
wish this book had been around when I was discerning ordina-
tion as a young woman. An excellent choice for church book
studies or retreats."

—Elizabeth Felicetti, author of *Unexpected Abundance: The Fruitful
Lives of Women Without Children*

"Every life has its moments—from challenges to achievements. Reading these moments with a deep sense of faith is the achievement of this remarkable book. Each vignette is manageable and moving. Reflection questions are provided. The result is a book that will invite you to read your own life—to see the grace in the rearview mirror. From childbirth to shoplifting, all of life is touched. Prepare to laugh, cry, marvel, and find grace in the most surprising of places."

—Ian S. Markham, dean and president, Virginia
Theological Seminary

"We look backwards in order to look forward. *Grace in the Rearview Mirror* by this select group of women offers an opportunity to listen to the beauty of God through lives lived. Here is offered a curiosity about God's beauty in our bodies, in our relationships, in our prayer, and ministry. Reading back into the lives of these women enables us to open our eyes wide to the possibility of God's beauty revealed in our own lives."

—C. Andrew Doyle, bishop of the Episcopal Diocese of Texas

Grace in the Rearview Mirror

Grace in the Rearview Mirror

Four Women Priests on Brokenness, Belonging, and the Beauty of God

BY

The Reverend Kelly Demo
The Reverend Mary Luck Stanley
The Reverend Samantha Vincent-Alexander
The Reverend Melissa Q. Wilcox

RESOURCE *Publications* · Eugene, Oregon

GRACE IN THE REARVIEW MIRROR
Four Women Priests on Brokenness, Belonging, and the Beauty of God

Resource Publications
An Imprint of Wipf and Stock Publishers
199 W. 8th Ave., Suite 3
Eugene, OR 97401

www.wipfandstock.com

PAPERBACK ISBN: 978-1-6667-5475-9
HARDCOVER ISBN: 978-1-6667-5476-6
EBOOK ISBN: 978-1-6667-5477-3

04/27/23

This book is dedicated to Riley and Asher, who teach me every day. —KD

I'd like to dedicate this book to Mark, Hannah, and Jack, who are the great loves of my life .—Mary

This book is dedicated to Adam, the one whom I always strive to love with abandon, and to my first church—Elias, Adelaide, and Josiah. It is in you that I have found grace in the rearview mirror. All my love always. —Melissa

My chapter is dedicated to my husband, Conor, who has stood by me in times of my greatest sorrows and greatest joys. —Samantha

Contents

About the Authors | ix

Introduction | xi

Chapter 1 *by Kelly Demo* | 1

 David 1

 On Prayer 3

 Glory Abides 6

 Stoby's 9

 Doubt 11

 The Chapter I Swore I'd Never Write 14

 Sunday Morning: Reflections on "Aaron,"
 a Poem by George Herbert 18

 A Time and a Place 22

Chapter 2 *by Mary Luck Stanley* | 26

 Forgiven 26

 Comforted 29

 Inspired 32

 Holy Hospitality, Solidarity, and Accompaniment 36

 Appearances 43

 Rescued and Claimed 47

 Ministry with a Baby on Each Hip 51

 God Moments 55

CONTENTS

Chapter 3 *by Samantha Vincent-Alexander* | 59

Angels in the Dive Bar 59

Foot Washing 62

The Fig Tree 67

#Blessed 74

Meeting the Birth Mother 80

Relinquishing One Privilege 86

Chapter 4 *by Melissa Q. Wilcox* | 91

Everything Happens for a Reason—NOT! 91

Roadblock to Bliss 96

Grandfather Michael and the Communion of Saints 100

Ritual or Routine: Raising a Child on the Spectrum
in the Church 104

Why Do People Keep Walking into My House? 109

"I Will, with God's Help": Baptism, Death,
and Grandma AD 115

The Pandemic and the Priesthood 118

Chapter 5: Instructions for Writing and Sharing
Your Spiritual Autobiography | 124

Acknowledgements | 127

About the Authors

The Reverend Kelly Demo is the author of *The Micah Paradigm: Building a Culture of Justice and Mercy in Your Church's Children and Youth Programs*, and is the associate rector of St. Thomas the Apostle Episcopal Church in Overland Park, Kansas.

The Reverend Mary Luck Stanley graduated from Texas A&M University and Church Divinity School of the Pacific. She has been a priest since 1997 and is co-rector of Old St. Paul's Episcopal Church in Baltimore, Maryland.

The Reverend Samantha Vincent-Alexander is a priest, wife, mother, writer, and sometimes yoga instructor, and is constantly in search of cute but marginally sensible shoes.

The Reverend Melissa Q. Wilcox is a graduate of Colby College and Virginia Theological Seminary. She serves as the associate rector at St. John's Episcopal Church in Carlisle, Pennsylvania.

Introduction

Listen to your life. See it for the fathomless mystery it is. In the boredom and pain of it, no less than in the excitement and gladness: touch, taste, smell your way to the holy and hidden heart of it, because in the last analysis all moments are key moments, and life itself is grace.

—Frederick Buechner, *Now and Then: A Memoir of Vocation*

T his book is for those who yearn to see and feel God, and who may be heartened to know that four women priests have discovered grace while looking back on their everyday lives. When the church refers to theological giants, men like Aquinas, Augustine, Luther, and Cranmer are mentioned. In this book, women named Kelly, Melissa, Mary, and Samantha share their theological reflections on discovering God's unconditional love in the midst of child-rearing, adoption, infertility, illness, overcoming sexism, and navigating married life.

We are four Episcopal priests who have a unique perspective because we are all married to priests, and we are juggling our ministries while raising children. With almost a century of combined years of ordained ministry to draw on, we share stories of God's love, forgiveness, and mercy, hoping our readers will recognize that God has been present and caring for them all along, even when that reality may have seemed hidden.

Gathered from four different parts of the country, we were invited into a small group for clergy couples by the Thriving in Ministry program, sponsored by Virginia Theological Seminary

and the Lilly Foundation. For more than two years, our group of eight (four couples) had monthly meetings online to talk about our ministries. At an in-person retreat, we took turns sharing our spiritual autobiographies, noting the ups and downs of our lives, as well as the times when we felt the presence of God. Between moments of quiet, laughter, and tears, we realized that four of us were not only preachers, but also writers. We stayed up late that night brainstorming ideas about writing this book together.

The presence of God is not only to be found inside beautiful churches and while praying in traditional ways. God's love will find ways to reach out to us through our work, family, and friendships, and even through the painful experiences in our lives. Our stories include standing up to the patriarchy with a child on each hip, seven years of undergoing fertility treatments culminating in adoption, drawing out the divine in a child on the spectrum, and finding enlightenment in the midst of struggling with cancer.

We invite our readers to take time out to reflect on their own life experiences, identifying the peaks and valleys, and especially noting the times when they felt God's presence. At the end of each section, we have provided discussion questions for your reflection. You may enjoy writing your thoughts in a journal or sharing them with a loved one. Book groups and retreat participants may want to explore the spiritual autobiography activity that our group did at our first in-person gathering. At the end of the book, in chapter 5, we have provided more information about how to write and present spiritual autobiographies. This exercise helped our group to reflect on past experiences, and to recognize God's grace at work in our lives.

Chapter 1
Kelly Demo

David

T he first time I met David, he was dead. This was supposed to be my husband's call. He had been working with the family. Late-night hospital visits, long painful decision-making conversations. He had walked with them for a long time through this valley. But he was out of town when the call came, so I was on.

I was warmly greeted as I entered the house. The living room had that pall of death that those who had lived a long time were at ease with and those who were younger didn't want to acknowledge. A dog was incessantly barking in the backyard, oblivious to the courtesy of hushed tones. I was escorted upstairs to his bedroom.

I stood in the doorway and looked around. Blue, green, and brown. A Pokémon poster on one wall and a dog poster on another. Model airplane on a shelf. "Get well" drawings and cards from his classmates taped to the walls. On the bed, surrounded by pillows and a dark blue comforter, David's tiny body, bald and pale, lay draped on his mother's lap like the Pietà. His mother was stroking his sweet face and his father was helplessly holding David's hand and playing with his pajama sleeve. It was quietly explained to me by his grandmother that the people from the funeral home were there and wanted to take David to begin the process of preparing the body. But his mother wouldn't let go, and could I maybe do something?

"Sweet Jesus, I can't do this," I silently prayed. A wave of inadequacy washed over me. Never have I felt so bereft of the knowledge of what I was supposed to do and the strength to do

it. Way back in my twenties when I was discerning the call to the priesthood, my biggest argument to God against the idea was that I was neither good enough nor smart enough to be a priest. I was the goofy kid who, according to most of my grade school teachers, "never really lived up to her potential." The awkward teenager who misread boys' social cues and struggled to live in the girl culture of the 1980s. The eldest child who desperately wanted to please her parents and so often thought she fell short.

And now, I had become a mother as well. There was no greater fear as a parent than the scene in front of me. I thought of my own beautiful children. I would never want to let go either. I would hold them in my arms, surround them with my body like a womb, and simply be buried with them, never ever letting go. "Sweet Jesus, I can't do this."

One of the beautiful things about our liturgy is that we say the same things over and over again. It is also one of the biggest complaints about our liturgy—the same thing over and over again. But when we do that, certain phrases become a part of us. "Ascribe to the Lord the honor due his name . . ." and "It is right and a good and joyful thing" As my liturgy professor said once, we are marinated in these words, and they become infused within our marrow.

I couldn't enter that room, of my own volition. As a mother, as a frail human being, I could not enter the void that had enveloped that beautiful boy's bedroom. I was not even conscious of summoning the words, but they came to me in that moment. From the end of morning prayer. "Glory to God, whose power, working in us, can do infinitely more than we can ask or imagine." God's power working in me, which can do more than I can imagine.

I took a deep breath, and I stepped through the door.

Reflection Questions

- Name a time when you felt in over your head. Where was God in that?

- Are there phrases from your church liturgy or Scripture that come into your head to bring you comfort?

On Prayer

"Dear Lord, good morning! Um, open my lips, O Lord, and my mouth shall proclaim your praise. Create in me a clean heart. Clean car. Man, why won't they get their junk out of the back seat? I get so tired of fussing at them. Oh. Forgive me, Lord, for fussing at my kids. I am trying. But they make me so crazy. They are so beautiful and perfect. We sure have had a lot of rabbits in the neighborhood this year. I wonder why. Sorry, Lord. Um, I love you, God. I offer this day up to you. Please bless my work. Because I really need it to get better. Because my little department is never going to make its numbers at this rate. I gotta get up and get to work. I wish Kathy would stop putting that candy out for people in her cubicle. I can't keep my hands out of it. Dark chocolate. Thank you, God, for dark chocolate. I wonder if anyone else posted about my status on Facebook. I love you, God. Please bless my day and my kids and my husband. And I have to go let the dog out now so she doesn't pee on the carpet again, so we'll talk again soon. Amen."

This has often been what my attempt at prayer first thing in the morning sounds like. A ridiculous circus train of thought. I am a priest, for heaven's sake. Aren't I supposed to be better at this kind of thing? People definitely assume that I am.

Then there are the times when God seems so far away that my soul can't shout loud enough into the void to be heard. I am told that God is everywhere. I preach that God is everywhere. But some days, some seasons of life, it does not feel like God is anywhere.

Other times God is so close I kind of wish she would stay out of my business. She is all up in my face with some new thing I am being called to do, and I need a little breathing room.

I firmly believe that all images and language about the Divine are inadequate. We use "he" and "Father" because that was handed down to us and it is easy. But we have grown to know that the image of "Father" is also fraught. Even "Mother" holds

3

plenty of baggage. Parental images of God can take our unful-filled needs, our anger, our longing for acceptance that we feel about our own parents and project them onto the perfect parent who actually does fill our needs, quell our anger, and accept us. God can take it, but it can keep us from a closer relationship because our issues get in the way. Creator, the Great Shepherd, Sophia, Jesus, the Holy Trinity—all are helpful images of the Infi-nite, but none are complete. Our little language is just too limited for something so big.

Because of this, our images often change over time depend-ing on our needs. When I was younger, I prayed to Jesus exactly like he was an imaginary friend. Very comforting when you are a lonely teenager to have Jesus sit on the edge of your bed, next to your dog, listening to your heartache.

As a young mother I talked to Mary, the mother of Jesus. She had seen it all and knew the grief and joy of motherhood at a depth no one else has ever known. She understood me when we talked about my fears for my children, my exhaustion, my pride, and my wrath. Mary is a female expression of the Divine who is less ethereal than Sophia, the feminine name of Wisdom used in the Hebrew Scriptures. Mary knew the blood, sweat, tears, and breastmilk of mothering, so she and I talked a lot.

As I have gotten older the focus for my prayer has changed. Instead of praying to something big and "out there," I find that I am thinking more about God at the subatomic level. Finding the Divine in the proton, the alpha particle, and neutrino. Surely the Creator dwells in something delightfully called the "charm quark." I learned that there is a vast empty space between par-ticles, so what dwells there? I am no scientist but the poet in me is intrigued. My prayer floats in that empty space, bumping around, moving, and nudging, and listening.

Big, small, close, far away, male, female, non-binary, incar-nate, celestial, three-in-one, one-in-three. All of it is very good and real and right. And inadequate.

The Bible offers so much in the way of comfort but, to my mind, there is no verse about this struggle more comforting than

Romans 8:26. "Likewise the Spirit helps us in our weakness, for we do not know how to pray as we ought, but that very Spirit intercedes with sighs too deep for words."

Paul, *the* Paul, the one chosen by God to spread the good news to the world, who started churches all over the Roman Empire, who has really big churches named after him, *that* Paul admits he doesn't know how to pray. I find that very comforting. He had actually seen and talked to Jesus and even he does not know how to pray well.

Instead, he says, we recognize that any prayer we attempt (including my morning pre-coffee rambling) is the movement of the Holy Spirit interceding, "with sighs too deep for words." It is my spirit connecting with the Spirit, communicating with the Divine in a language that is beyond language. And it is not my doing; it is God's doing.

Reflection Questions

- What images of God resonate with you?
- How has your prayer life changed over the course of your life?

Glory Abides

O LORD, I love the house in which you dwell and the
place where your glory abides.

—Psalm 26:8

I couldn't breathe. I had heard the phrase "have the wind knocked
out of you" but I didn't know it was an actual physiological response. But as I stood there looking at the charred pews, the water
dripping from the vaulted ceiling, the violent emptiness of it all, I
had to concentrate to make myself breathe.

The bastard had sneaked into the chapel, which was easy
because it was always open so people could come and pray at any
hour. He had the audacity to stack and then burn Books of Common Prayer in the corner so the fire would creep up and over
the wall from the chapel into the sanctuary. He had done this to
other churches; he knew what he was doing. Years later, I would
be back at this church to preach and celebrate the Eucharist in
the new sanctuary, on the day the local newspaper announced
the arsonist's arrest. I quickly changed my planned sermon to acknowledge our collective grief and talk about forgiveness. I was
preaching to myself, and I wasn't really buying it.

This place, that sanctuary, was my bedrock. As a priest I know
and tell people that the church is not the building; it's the people.
But, when so many life events, so much learning, so much spiritual
connection happens in a building, that place becomes a profound
presence in your life. Like a warm and wise grandparent who has
just always been there, you never expect them to go.

As a child I remember my hard-soled shoes making a lot of
noise on the light blond wood of the pews; vacation Bible school
on hot summer days when I got to lay on the cool tile floor, listening to the story of David and Goliath. I remember the red kneelers
and learning to genuflect before coming to Communion.

I was so nervous the first time I got to acolyte that I couldn't wrap my head around how to tie the cincture. I stood there holding both ends of the rope with tears welling up in my eyes when an older teen, the prettiest and coolest acolyte there ever was, came over and kindly helped me learn the knot. I carried a torch and got to sit next to the deacon during the service. Harry was a gregarious and holy man who would always lean over and say something funny, just to get me giggling. He taught me that church is supposed to be joyful and fun.

I was an altar rat. Any chance I had to acolyte, I would. I loved the feeling of being at the altar, learning all the names of the tableware: chalice, paten, purificator, and my personal favorite, lavabo. Lavabo. So much fun to say. Because I was always there, I got to do and learn all of the behind-the-scenes duties. Eventually I became the first girl thurifer. In that role, one Easter I almost burned down the church myself. As an acolyte I learned how to learn from mistakes.

I got to buy a new white dress for confirmation. I got to train younger acolytes. I learned Midnight Mass is not some different kind of church. It is just regular church but at midnight and with Christmas songs. But it is still kind of magical.

The congregation gathered around to lay hands on me before I left for Africa. They gathered again at my wedding, and again as I celebrated my first Eucharist as a freshly minted priest. I tasted the heavy sweet incense smoke. I felt Mary Cohoon's soprano voice from the choir loft.

The centerpiece of the sanctuary was a massive and resplendent Christus Rex hanging behind the altar. Made of bronze and tile, arms outstretched, he wore a robe, a priest's stole, and a crown. Church lore says that the local artist who designed it back in the sixties had wanted to put a jester's hat on his head to reflect the idea in First Corinthians, "For the foolishness of God is wiser than man's wisdom" A lovely idea but the church ladies were having none of that.

How often as a child or teen did I sit in those pews looking at the regal, stern, kind face of Jesus and both hope and fear he

would smile at me? As a child looking for affirmation of love, as a teen looking for answers. Hell, even as an adult looking for . . . something. Some slight movement to give me a sign, one that only I would see. Like the boy Samuel, who heard God's voice in the temple, "Here I am," I'd whisper.

My breathing turned to quiet sobs. That room that was so familiar, packed with so many memories, it now felt eerie and defiled. The rector of the church, who brought me in to see what happened, was telling me the details of the fire or something, but I didn't really hear what he said. The rich modern stained-glass windows were completely covered in toxic ash, so the room was almost totally dark. Except for one place.

Once I noticed it, I had one of those crazy laugh/cry sounds come out of my throat. It was too cheesy. Too perfect. Too cliché. But there it was. The firefighters had torn open a hole in the roof of the sanctuary so they could spray water into the building. That was the only place where light was coming in. As God is my witness, there was a beam of light shooting through the blackness and shining directly onto that magnificent face of the Christus Rex. One last lesson this beautiful place had for me: the reminder that no matter how dark, how violent, how toxic life seems, the resurrection is real, and glory abides.

Reflection Questions

- What are your memories of your childhood church?
- Has there been a time in your life when the loss of a thing (a building or an item) felt like a death to you?

Stoby's

For about four years we lived in Conway, Arkansas. Conway is just outside Little Rock ("Smack dab 'tween Toad Suck and Pickle's Gap, Arkansas"). Being from Kansas, I thought, "How different could it be? It's just one state over and one state down." Wow, was I wrong. Arkansas is definitely the South. With all its charm, mosquitoes, and issues.

There was a little dive in town called Stoby's that had the best pancakes and grits. Yes, I did get hooked on grits while I was there. Don't judge me. Biscuits and gravy, frog legs, fried greens. All the great home cookin' of the South. However, it was also one of only two places in town that had a drive-through where I could get caffeine-free Diet Coke. I was an addict. I can't lie. And when you have two little ones in the car, you will resort to *anything* that is drive-through. I put up with a very crotchety lady who worked at the dry cleaner's and suffered a man who looked at my boobs every time I picked up my prescriptions. Why? Because they had drive-through and I didn't have to endure the Houdiniesque procedures that were getting a child in and out of a car seat.

So, one day I am in the car line waiting to get my yummy caffeine-free Diet Coke. It takes forever. I have a limited window of time while the child in the backseat is sleeping. The person in the car in front of me reaches in the drive-through window and gets his food. Great. Now we will get moving. But we don't. We are still sitting there. For a long time.

Then it hits me. They are chatting. Damnit. It's a Southern thing. Now, we Midwesterners are friendly. We are the masters of small talk. But Southerners chat. They have to go through who their mutual friends and family members are. They have to talk about what the pastor said in church on Sunday and what the neighbor's kid said to the teacher on Monday. There are illnesses

to be diagnosed and symptoms to be compared. I am never going to get my Diet Coke.

As I am sitting there stewing about how there is a socially acceptable limit to friendliness, I see the hand of the man in the pickup truck in front of me reach out to shake the hand of the man who is working the window. The hand that comes out of the truck is that of a White man and the hand coming out of the restaurant window is that of a Black man. A strong, friendly handshake and the man drives off.

All these years later that image is burned in my brain. I think of it every time I see my children playing, without a second thought, with children whose skin colors run every lovely shade found in the human spectrum. I also think of it when violence erupts over a racially motivated killing. I remember that handshake when I hear our Black president speak and when I read icky things on Facebook that people say about Muslims, Jews, immigrants, or anyone else who can be easily blamed.

It was a moment that pulled me out of my ignoble immediate desire for an easily obtained Diet Coke and reminded me of the importance of human connection, of the need to be a genuine neighbor who can listen, reach across boundaries, share stories and, yes, chat.

Reflection Questions

- Describe a moment when you witnessed a lovely human connection.

- Has there been a time in your life when God pulled you out of your immediate wants or needs to realize her movement in the moment?

Doubt

I t is a painful thing to be a priest and not believe in God. It started on Easter, of all days. My husband was taking his post–Holy Week nap (the sweetest and deepest nap of them all). Both kids were napping at the same time too, which in itself is an Easter miracle. I was folding baby laundry, which is both lovely, with the smell of Dreft, and annoying because one load always includes over three-thousand tiny pieces of clothing. I was watching a documentary about brain research.

On the show they talked about how they could stimulate a person's brain to make them feel certain feelings. They showed test subjects sitting in a lab with little electrodes and wires hooked to their heads. Then the narrator said that in several studies researchers were able to stimulate the feeling of the presence of God by activating one part of the brain.

I felt a cold sweat come over me.

They said that scientists believe that humans developed this part of the brain as a coping mechanism because, as far as they can tell, humans are the only animals who are aware of their own mortality. We know we are going to die someday, so to deal with that and be able to function without going mad, humans developed the idea of a being larger than ourselves; that gives us purpose, guidance, and a place to go when we die.

I had been one of those weird teens who never questioned the existence of God. Most of my friends did at one point or another. I know now that rejection of what we are taught about God is a natural stage of growth in humans. I was thirty-five at the time and I had never questioned the existence of God because I had felt God. On so many occasions in my life I had felt God as clearly as I feel the computer keys under my fingers as I type this. Singing hymns, being at church camp, sitting in quiet prayer, God was tangible to me. That was objective evidence that God existed.

Now I was being told that I simply have an overactive section in my brain that makes me feel God so that I can function in life instead of facing the truth of the black void that awaits me when I die? There is no God.

I felt the ground crumble underneath me. Looking back, I think about a news story from when I was in college—Baby Jessica, who in 1987 was trapped in a well for over fifty-six hours. I was in that well and falling. Falling fast and farther away from God. I couldn't see light at the top; I couldn't get a foothold to make myself stop. I just kept falling. For a year.

It is a painful thing to be a priest and not believe in God. We have a great pension plan. I loved my job. Fortunately, I was doing youth work for the diocese, so I did not have to celebrate the Eucharist during that year. I am not sure what I would have done, because it certainly would have felt hypocritical. There was no God, and I was going to need to find a new boss.

I reached out to several people for guidance, to no avail. My bishop, very wise man that he was, was flummoxed and didn't know what to tell me. My husband, other priests, friends—no one had any answers that made the falling stop.

Oddly enough, it was an agnostic therapist who intervened on behalf of God. I was seeing him to talk through a few other things going on in life and I hesitantly brought up this subject. It is laughable that I thought I was able to compartmentalize the death of God and think instead that I could just chat with him about normal therapy issues: parental approval, self-medicating. You know, the run-of-the-mill stuff. All the while there was a massive cavern of nothingness inside me as I contemplated the cavern of nothingness that awaited me someday.

I told him about the brain studies. About the area in my brain that apparently invented God. About how I had always felt God but now I knew better. About the pain I felt in knowing the truth.

He was quiet for a moment and said, "Well, you know I am not really equipped to talk about this kind of thing. But I can tell you this. When someone is having brain surgery, the surgeon can stimulate one part of the brain to make that person feel full sexual arousal

and orgasm. That experience is no less real than actually having sex. Maybe it is the same with experiencing God. I would think if there is a God, that God would need some way to communicate with you. Maybe there is a part of the brain that does that."

In my mind, my arms thrust out and slammed into the sides of the well. Dirt was falling on my head, but I had stopped. I had something to hold on to. God gave me that part of my brain precisely so I could feel that presence. Maybe monks and people who meditate have developed that part of their brain to be bigger than most? Maybe for atheists that part of the brain is not as large, so that feeling is inaccessible? Maybe there was a God.

It took me a long time to dig out of the hole, but when I did, I had a much more mature faith. Hell, I would say that for the first time I actually *had* faith. I had certainty before. Faith is a choice. I choose to believe in God. I choose to develop that part of my brain through prayer so we can talk and listen more clearly.

There are still times of doubt. Times when I fear the darkness again. But I choose to believe in a grand presence who is patient and loving. I know now that the whole time I was falling, God was actually holding me close. I know it because I can feel it.

Reflection Questions

- Have you ever experienced a time of doubt?
- When have you felt the presence of God?

The Chapter I Swore I'd Never Write

The first thing I learned was that the word "cancer" is akin to the name "Lord Voldemort." In the wizarding world of Harry Potter, the villain, Voldemort, was so evil that the very name evoked fear and death. He was to be referred to as "You-Know-Who." Nobody wanted to say his name. Similarly, saying "cancer" evoked fear and the possibility of death. Saying "cancer" made it real and surely it wasn't real. So we called it "the thing," as in, "Well, once we find out more about the thing, we will tell the kids."

After the first shock wave had passed, after the discovery of the mass in my kidney, I thought, "I am *not* going to write about this. Too maudlin. Too predictable. Too selfish." I am not going to Facebook about it, I am not going to journal about it, and it will not go in the book that I *will* someday write. Millions of words have been written about journeys with cancer. I have nothing more to contribute. And, well, I am too damn scared to write about it.

And yet here it is.

Spoiler alert: I am fine now. A charming silver fox of a doctor removed the kidney and, *voilà!*, I am cured. Because of this I was even less inclined to write about what happened. I did not have to endure the sickening hell that is cancer treatments, my life is no longer threatened, and things quickly returned to normal. How dare I presume I have anything more to say on the matter? My experience was nothing compared to what I have witnessed friends with cancer endure. But that was one of the other lessons; I had no fucking idea.

I had no clue how scary a diagnosis could be. When I got the news, I had to picture the possibility that my kids might have to live out their childhoods without me. I had to picture all of the things that I had planned to do and hadn't yet. I had to picture my husband planning my funeral, my mom and dad burying their child. I viewed the abyss from a hospital bed and was

terrified. I would love to say that I prayed and felt God's presence in that moment and knew that all would be well, but I didn't. I was consumed with fear. Looking back, I know that God was present, but when all you can see, feel, smell, hear, and taste is fear, there is no room for God.

I had no clue about a thousand little things. How do I tell my friends and family? What will the financial reality of this be? How do I hand off my projects at work without sounding like a drama queen? Will I get those projects back when (if?) I go back to work? Am I getting mad at the person in the car in front of me because he cut me off or because I might have cancer? Can I trust what the internet says about this? Do I get a second opinion? Is this the morphine talking? Should I be honest with people when they ask me how I am doing? Do I continue to let my husband shoulder all my stress while I continue to be seemingly carefree and nonchalant in a stupid effort to seem brave to the rest of the world? Do I call the surgery scheduler lady *yet* again because she hasn't called me back, and doesn't she know how everything in my life is put on hold until I get a surgery date, and who the hell does she think she is?

I had no clue how bad I am at asking for help. I had no clue just how overworked and underpaid nurses are. I had no clue as to the indignities of being sick. It only takes one incident of not making it to the hospital bathroom in time to learn these lessons.

It was because I had no clue about these and a great many other things that I learned my next big lesson. Even after three years of seminary training and over twenty years of ministry, I realized that my responses to people who are going through something that I have not been through fall woefully short. I mean, I think I'm a pretty pastoral person. I can listen well, comfort people, pray at a moment's notice. (Sometimes even without using the Prayer Book. I'm that good. Sometimes.) But I think this experience has allowed me to internalize the difference between sympathy (acknowledging another person's emotional hardships and providing comfort and assurance) and empathy (understanding what others are feeling because you have experienced it yourself).

For instance, I have not yet suffered the loss of one of my parents. I can only imagine that the grief when a parent dies is a particular kind of grief, different from when someone else dies. But I have not experienced it yet, so I don't know what it feels like. So, when a friend's parent dies, I can only carefully sympathize, but I cannot empathize. This may not seem like a huge revelation, but it is an important one because it does two things.

First, it helps me (for the most part) refrain from saying stupid things. A few years ago, a friend called me in tears saying her mother had been diagnosed with cancer. After talking for a while, in an effort to help I stupidly said, "I just heard a doctor interviewed on NPR say that you should take your time in choosing cancer treatments because cancer isn't an emergency." Now, I knew what the doctor meant. I knew what I meant. But all my friend heard was, "What you are going through right now is not an emergency." Not my best pastoral moment. Having now been through a cancer scare, I know that in that moment it is a five-alarm–stop-the-presses–all-hands-on-deck–code-red-level emergency.

Realizing the limitations of my empathy, I now know I need to *always* do more than I may think needs to be done. Check in with people more because they need it more than I realize they do. Listen more because whatever it is they are dealing with is more fraught with emotion than I can possibly know. Be more patient because there are a thousand things that they are experiencing that I am clueless to. Bake them chocolate chip cookies because they heal the soul. And the dough is delicious.

Which brings me to my final lesson learned in this saga. I love my body. I have a damn fine body. I have a floppy belly, boobs that are approaching my belly button, I can't comment on my ass because I can't see it, and my legs look like a subway map made out of veins. But I love it. And this is a huge deal for me to say this.

Like most women (and men?) I have had a lifelong struggle with my body. In hindsight I have always been ashamed of my body and that is a shame. This earthly vessel has taken me around the world, made two people, and allowed me the joys of sex, food, music, the smell of fresh bread, and the sight of my kids being nice to

each other. I have loathed this body and in return it has lovingly carried me for nigh on fifty years. And to top it all off, it can have a major organ removed and still kick ass. I have a damn fine body. *Sports Illustrated* would do well to feature a swimsuit issue on me.

I know there are many who feel that God controls everything and that when bad things like cancer happen, God is testing us or has something to teach us. But I think God loves us too much to make bad things happen to us. Bad things just happen. We live in a physical world, one with tornadoes and leukemia and drownings and sin that causes other bad things like war and murder and global warming. However, one of the things God is best at is making lemonade out of the crap lemons that we make of our lives. God does not send bad but can bring good out of the bad. God didn't want Joseph's brothers to sell him into slavery, but when they did, he used the opportunity to set in motion the claiming of the Israelites as his people. God didn't want people to be hurt and killed in the Civil Rights Movement, but when they were, he used it as an opportunity to change the minds and hearts of the rest of the country, and move us farther along on the arc towards justice. God didn't give me a mass in my kidney, but I will always be grateful that because of the mass in my kidney she helped me to be a better pastor and to appreciate more fully this life that was given to me.

Reflection Questions

- Why do you think bad things happen to people?
- Talk about a lesson you have learned through hardship.

Sunday Morning: Reflections on "Aaron," a poem by George Herbert

"Death used to be an executioner, but the gospel has made him just a gardner [*sic*]." It's little gems like this that make me such a fan of George Herbert. Writing in the early 1600s, he was an Anglican priest to a small rural parish outside Salisbury, England. What I love about his writing is that even though he lived over four hundred years ago, his experience of ministry, of the love of God, and of his parishioners feels very familiar to my twenty-first-century ears. The poem "Aaron" is an example of the timelessness of his writing and of our shared reality as clergy.

> *Holiness on the head,*
> *Light and perfection on the breast,*
> *Harmonious bells below, raising the dead*
> *To lead them unto life and rest.*
> *Thus are true Aarons dressed.*

On any given Sunday, during that liminal time while the congregation is still singing the opening hymn and before I begin the opening prayer, I take a moment to pray in front of the altar to ready myself to celebrate the liturgy. I ask God for guidance to lead the people gathered in a meaningful time of praise. I get excited wondering what the Holy Spirit has in store for the morning. Sometimes, when there are several verses left in the hymn and my mind can wander, I think about Aaron, Moses' older brother and God's first priest. I think about the long lineage of priests who came before me. It gives me strength. It also makes me smile because as I picture the long line of clergy throughout history, they are all men—men who would probably not be happy I am standing there, dressed like them but with earrings and pink

manicured fingernails. And I think, "Hello, boys! Here we go!"
Thus are true Aarons dressed.

There are so many wonder-filled moments in the liturgy. Brief moments of tension wondering if the lector has shown up to read the lessons, and relief when they stand and make their way to the lectern. Saying the beautiful and ancient words of the Creed and praying for the vastness of humanity in the Prayers of the People. The kids in children's church come running back into the nave to find their parents, waving whatever craft they've made that connects their story with Jesus' story.

I cherish saying the Eucharist. As Episcopalians our heritage is Elizabethan with its soaring language. Even with a 1979 version, often the words we use are unlike words we use in our everyday conversation: "joining our voices with angels and archangels," "sacrifice of praise and thanksgiving," "the innumerable benefits procured unto us by the same." Delectable. The words feel good in my mouth.

I let the music, beauty, warmth, and comfort of the liturgy surround me like my favorite old flannel shirt. *Thus are true Aarons dressed.*

> *Profaneness in my head,*
> *Defects and darkness in my breast,*
> *A noise of passions ringing me for dead*
> *Unto a place where is no rest.*
> *Poor priest, thus am I dressed.*

There is one moment in the Eucharist, however, that I dread. It is a weird, quirky thing and I don't know if any other priests feel this way. I have always hated the moment during the Eucharist when I lift the chalice and say, "This is my blood of the New Covenant" It isn't that I don't like the words or I question the power of what is happening in that moment.

When I lift a silver chalice, I can see a distorted, freakish, funhouse-mirror version of my face.

It is disconcerting, and somehow terribly vulnerable. In that moment when I see my warped face, I feel like the whole

congregation can see the truth about me: grotesque, corrupt, base. It was Aaron, after all, who made the golden calf at Mount Sinai. Faithless. With this aberrant reflection in the polished silver, I see all of my flaws on display like a carnival sideshow. *Poor priest, thus am I dressed.*

> *Only another head*
> *I have, another heart and breast . . .*

Yet then, in the very next moment, the real joy of my job comes. I have the hallowed privilege of distributing the body and blood of Christ to the true priests of the church. I get to see up close the beautiful faces and hands of Christ in the world. What is so thrilling for me is how different Christ's hands can look—all of them finding their own way in the world, serving God as best they can.

Hands cupped together reaching out to receive the outward and visible sign: wrinkled and shaky, tiny and new, tan and calloused, missing a finger, boney, fat, colored with markers from Sunday school, or a stamp from a bar they were in the night before. Scarred from self-inflicted pain, wedding ring, sticky with jelly, tattoos, painted fingernails, and fingernails with dirt and grease caked under them. Hands that are so new to the world that they stay in a tight fist, ready to take on the world; hands steady and strong and steeped in life; and hands that are almost done with their work in this world, thin, ghostly, fragile.

As I place the bread in their hands, I try to lock eyes with them, just for a moment.

> *Only another head*
> *I have, another heart and breast . . .*

I see in their eyes the redemption, grace, and kindness of Christ. This body, this blood that we share together, that dwells within each of us, connects and heals us and we are made one Body.

The closing hymn begins, I gather my things and my thoughts to process out, shake hands, chat during coffee hour, and head home

for lunch and a nap. As I change out of my slightly uncomfortable, cute-yet-sensible shoes, black clergy shirt, and white collar to get into my comfies, I smile and think about the morning.

So, holy in my head,
Perfect and light in my dear breast,
My doctrine tun'd by Christ (who is not dead,
But lives in me while I do rest),
Come people; Aaron's drest.

Reflection Questions

- Why do you go to church? If you do not go to church, why?
- What are the moments when you find God in your workplace?

A Time and a Place

I turn the car onto the dirt road much more slowly. That's the wisdom of time. I used to take this roadway too fast until once, on a curve, I almost bit the dust. I had always hoped that if I ever faced a life-or-death situation, my thoughts would immediately turn to prayer. Prayer for what I was not sure, but I liked the idea of thinking of God first when my life was in danger. Instead of prayer, what came out of my mouth was "Shiiiiiiiiiiittttt!" as I tried to gain control of my sliding tires. Maybe that was my prayer.

So, now I drive slowly. I love this little road that leads to camp. It is the road where I leave my normal day-to-day church life behind and turn my mind to the week ahead. Always the first full week of June. My father and grandfather went to this camp. My husband even proposed to me down by the lake. Most years I am the chaplain for the senior high campers. Many years ago, I ran the whole program for our diocese. Before that I was a counselor and before that a camper.

But I only attended as a camper one time. One of our traditions is a cardboard regatta, where campers build and race boats made out of cardboard and duct tape. My freshman year of high school, the one year I went, I was asked to captain a boat built by a group of friends. As soon as I got in the boat it sank, which I thought was hilarious. So, being the strong swimmer that I was, I pulled the boat, like it was a dead body, through the muddy lake water to the finish line. Everyone cheered. But later a counselor made fun of me in front of the rest of my cabin mates for being so fat that I sank the boat. So I didn't go back until years later, when I became a counselor. I wanted to make sure that never happened to anyone ever again.

I bump over the railroad tracks and see the dead branches of the town of Elmdale. A decomposing bank building, built in 1898. And Bummies, the legendary five-and-dime that used to

make the best milkshakes. Where "back in the day" senior high kids at camp would sneak off to buy beer. The shells of both buildings stand strong, made with blocks of limestone drawn from the nearby quarry. Two empty mobile homes overgrown with weeds, the cement foundation of a house that is no longer there, and an abandoned tractor complete the picture of a Kansas town that once was.

I turn south and can see the dining hall about two miles away perched on top of a high hill. This camp is in the heart of the Flint Hills. People say that Kansas is "flat as a pancake." Apparently, that assertion has even been researched by topographers who looked at the landscape of a pancake and mathematically compared it to the landscape of Kansas. The conclusion to that study was that Kansas is, in fact, *flatter* than a pancake. Whatever. I like pancakes.

Maybe that is part of what makes this area so special. Out here it is not flat. The Flint Hills are a unique part of the massive tallgrass prairie ecosystem that runs through the Midwest. Hundreds of miles of rolling hills covered in grass that can grow up to ten feet tall. There is even a nature reserve not far from the camp where, yes, buffalo roam.

As I make my way down the road, the rocks crunch and pop under my tires. It rained recently, so the dust is not kicking up as badly, which is nice. I begin to focus my thoughts on the week ahead. One hundred and thirty-seven kids will show up tomorrow afternoon with a giddy mixture of joy and apprehension. I always tell new counselors that I feel we are lucky to get these kids the first full week of June. Most of the campers are just coming off their school year and when they get to us their buckets are empty. Exhausted from a year of school, homework, crushing expectations, active shooter drills, and the mercilessness that can come with the routine existence for children and adolescents, we get to receive them with affection and have a week to build them up and refill those buckets. They get to be silly. They get to run in the sunshine and ride horses and swim in a lake that is so muddy you can't see the bottom, but no one cares. They get to ask questions about God and themselves and they get to make s'mores while they are doing

it. You can't help but have questions about God when you see the Milky Way for the first time ever. They make friends and friendship bracelets and create goofy skits about loving your neighbor. There is the inevitable summer romance and a bee sting.

One highlight of the week is the "MegaEucharist" on High Y. On Wednesday night at dusk, all three camps, elementary, middle and high school, gather on the highest point of the camp, called "High Y." An amphitheater that has been carved into the side of the hill overlooks a grand stone altar. Trying to do actual church in this space is often a little slapstick. The wind never stops and between the lovely meadowlarks and the invasive train horn in the valley below it is hard to get a word in edgewise.

But, oh, the view. The point where the earth curves out of sight is a good twenty miles away. To the west you get to witness the titian red vesper light as it sinks below the horizon. In the valley is a line of trees that snakes alongside the creek. Highway 50 is paralleled by the train tracks. And more often than not, somewhere off in the distant sky a storm builds. A Kansas thunderstorm. The roiling cumulonimbus clouds tower upwards of thirty, forty, fifty, even sixty thousand feet. Lightning spasms from within the cloud and finally bayonets the ground. So much power and destruction and beauty and foreboding; it is both thrilling and terrifying. One year after a particularly spectacular display off in the distance we had to cut our MegaEucharist a little short to get everyone inside to safety. As the thunder got closer and the air got still, I heard one camper observe, "Man! God really showed up tonight!"

Theologian Richard Rohr writes that "The first act of divine revelation is creation itself. The first Bible is the Bible of nature."[1] He teaches that we can see the sacred in everything around us. Love is coursing through every blade of grass, every farm pond teeming with life, the grazing horses, the angsty teen, the spider in the corner of the cabin. All of creation is an expression of love and by watching it, embracing it, enjoying it, we can know God

1. Rohr, Richard, "The First Bible," *Daily Meditations* (blog), February 28, 2016, https://cac.org/daily-meditations/the-first-bible-2016-02-28/.

more deeply. Just as Scripture helps us to understand the Divine, so too can all of creation.

I slow the car to a stop. This is my favorite part of the drive. My favorite part of this annual ritual that sets me right before a crazy week begins. On either side of the road are small fields of winter wheat. This is what grounds me to this place and this time. Ripe and ready for harvest, the stalks are all uniform in height, whiskery heads atop leggy stalks. They beg you to skim your hand across the tops as hydrangea and peony blossoms demand you pat them on the head when you pass by. In another week or so it will be the farmer's turn to harvest and a crew will come to scoop it all up. But for now, in the bright sun, the playful amber waves are simply there to preach to me the good news.

Reflection Questions

- "The first Bible is the Bible of nature." Do you believe this is true? If so, talk about a place that is sacred to you where God speaks through nature.

- Our planet is changing rapidly. What role does God play in that change?

Chapter 2
Mary Luck Stanley

Forgiven

In seventh grade, I started going to a new school where I didn't know anyone. When a girl I met in science class invited me to walk down to the local shopping center one Saturday morning, I was excited. But as soon as we got there, I felt uncomfortable watching my ten new friends climb into grocery store shopping carts and push each other around, having races in the parking lot; this group was rowdy!

We wandered over to the drugstore to get some candy, and before we walked in, someone in the group said, "I dare you to shoplift something from this store. Everyone has to do it, or else!" We waited outside as people went in, one by one, and came out to show us what they'd stolen: a pack of bubble gum, a deck of cards, a bag of M&M's. Each time, the group cheered, and after everyone else had taken something, the ringleader of the group turned to me and said, "You're up. Make us proud!"

Walking through the aisles of the pharmacy, I felt like crying as I fretted about what to do. I could see my friends impatiently hanging around, and I knew they were waiting on me. Seeing a wooden bin stacked full of colorful plastic combs, I reached out, took one, and put it in my back pocket before rushing to the exit. Just as I opened the door to leave, I felt a hand on my shoulder, and the man behind me said, in a gruff voice, "Little lady, what do you think you're doing? I was watching you and your friends on the security monitor, and I saw what you did. Come with me!"

Tears streamed down my face as I watched my friends run away. The man led me to a little office in the back of the store, and said, "You've been a very naughty girl! I'm calling your mother, so write her phone number on this piece of paper and wait here until she arrives." I sat in the only chair in the room, facing the desk with the security camera monitors.

When my mom finally arrived, she and the man came back to the office, and the man said to me, "I can see you're from a nice family, and that you feel badly about what you did today. Your mother assures me there will be consequences, and you will learn your lesson, so I'm going to let you go with just a warning." My mom walked me to the car, where we sat in silence for a while, just breathing, before she started driving. As we got out of the car, Mom said, "Please stay in your room for the rest of the day, until your father gets home." It was the day before Easter Sunday and since my dad was an Episcopal priest, he was busy all day, getting ready at church. All afternoon, I cried on and off in my room, worried about what would happen and feeling terrible about myself. At times I could hear my mom talking on the phone with her friends from church; she was telling them the whole story.

As the afternoon sun was fading, I heard a knock at the door. Dad poked his head into the room and said, "Mary, I heard about what happened today, and we need to talk about it, so please come to dinner." As I sat at the table with my family, my dad gave a speech, saying, "Mary, you know what you did today was wrong. But we want you to remember that you really are a good person. We trust that you will never do something like this ever again. Today is the day before Easter, and this evening at the Easter Vigil we will celebrate the resurrection of Jesus, so we want to invite you to begin living a new life." My mom stood up, handed me a box that was beautifully wrapped in colorful paper, and said, "So, to celebrate the beginning of your new life, we bought you this new Easter dress to remind you that you can always be forgiven and make a fresh start, with God's help." I opened the gift box and found the most beautiful yellow dress.

After dinner, I washed the tears off my face and got ready to go to the Easter Vigil at the church where my father served, the church where I had grown up. The yellow dress fit me perfectly and I put on my white patent leather shoes to go with it. On the way to church, I thought, "Ugh! Now I have to face the church ladies."

As we got out of the car, my mom's closest friend saw us and came rushing toward me with her arms outstretched, exclaiming, "On no, you poor thing, what a terrible day you've had. Happy Easter, Mary, and welcome to your new life!" After the hug, she handed me a tiny gift box with a bow on top. "Thank you" was all I could say. Then another one of the church ladies came rushing toward us, handing me a card and saying, "Happy Easter, dearest Mary!" This happened several more times as the church ladies gave me flowers, gifts, and cards, saying things like, "Happy Easter! It's time to make a fresh start!"

At the Easter Vigil that night, the words of the traditional hymns lept off the page and had new meaning for me. I sang, with a fresh understanding of God's forgiveness, compassion, and mercy, and with a profound sense of gratitude for my parents and the generosity of our church friends.

Reflection Questions

- Recall a time in your life when you experienced being forgiven. What difference did that make?

- Is it more challenging to forgive others or to forgive yourself?

Comforted

Lying on my bed, listening to albums on the new stereo I got for my fourteenth birthday, I heard a knock on the door and my mom poked her head into the room. Sitting on the end of the bed, she said, "You know I'm having surgery tomorrow, right?" Her diabetes was affecting her eyes, and the doctors were going to perform a procedure to try to save her sight. "Remember that song we always sing in church called 'Surely It Is God Who Saves Me'?" Sitting there on my bedspread with the big yellow flowers, my mom and I sang that song together.

The next day, in her hospital room, Mom asked me and my dad to sing the song with her again. It was hard because tears were burning in my eyes. After we sang the song, it irritated me when my dad opened his prayer book and read prayers for healing, inviting me to lay hands on my mom. In my mind, those prayers, written by someone else and printed in a book, were not good enough, and I had little confidence that it would do any good to pray for her. Still, I took her hand, closed my eyes, and begged God to let her see.

What I didn't know then, as a teenager, which I do know now, is that there are times in life when there are no words or prayers that could possibly seem good enough in certain times of crisis. Working as a hospital chaplain in the pediatric oncology unit, I was often called upon to offer prayers for children undergoing cancer treatment, surgeries, and even last rites for the dying. Parents would gather around their child's hospital bed, and I would say, "Let us pray," bowing my head. I was grateful to be able to read out loud from my *Book of Common Prayer* because at times, if I had prayed spontaneously, I might have started crying. Or even worse, I would have been unable to come up with any words at all, and then I would have been of no use to the family. Sometimes I was able to pray spontaneously, but never in the most critical situations. I'm guessing my father's choice of reading

prayers from his book, instead of praying spontaneously, was because he was so upset as he braced himself for the possibility that his wife might go blind. I'm sure my mom knew that and was comforted to hear the traditional prayers as we held hands and did the best we could to ask for God's help.

In the year that followed, Mom had several more surgeries to try to save her sight. Each time, we sang that song as she prepared for surgery. Each time, Dad read prayers from his book. Mom told me that as they were wheeling her bed down the hallway to the operating room, she tried to sing the song over and over again, like a mantra, to get herself into the right mindset. After each surgery, I cried, feeling frustrated that our prayers were not making enough difference.

The surgeries failed to restore her sight, and eventually she was totally blind. My mom was able to go on living for several more years, long enough to attend my high school graduation and get me prepared for college. She said these goals were on her bucket list, along with seeing me get married, which was an event she did not live to see. Even though the surgeries were not successful, I suspect she sang that song to remind herself of what was ultimately important. Her sight was important, for sure, but so were a lot of other things, like her feeling of being connected with family, friends, and God.

Throughout history, people have used songs and poetry to bring comfort in times of crisis. Certain sayings, prayers, and lines of scripture have stood the test of time, being passed down to children who have then shared them with the next generation. We know from the study of neuroscience that music has a way of bypassing the rational part of the brain, being processed and stored directly in the emotional part of the mind. Singing words allows them to carry a deeper and more emotional meaning, and the world's great religions have consistently used singing to comfort, uplift, and inspire. The reason we teach our children to memorize hymns, scripture, and prayers is that we want them to have these words situated deep within their minds and hearts, readily available for any occasion.

My mom's song has become my song, and I know that whenever I sing it, I will feel connected to her, to myself, and to God.

Reflection Questions

- Looking back on times when you experienced a crisis, did you feel more connected to God or less connected to God?

- If you were going to write some words on a piece of paper to carry with you in case you or someone else needed comfort in an emergency, what words would those be?

Inspired

"Your mom is the funniest person I know," said Mrs. Klinghoffer as she bent down to shake my hand one Sunday after church. "That Halloween costume she wore at the party the other night was hysterical," she added. There was something in her tone that wasn't funny or appreciative. I didn't have a word for it then—I was only seven years old—but now I'd identify it as disapproving.

I was used to people coming up to me at church, making comments about my family, or asking me to deliver messages to my parents. My dad was an Episcopal priest at our church and led daily chapel for the school I attended, and my mom was very involved, especially with the women of the church. Growing up in that church, I felt we were part of one big family, celebrating holidays together and going on camping trips up at the lake. I didn't understand some of the adult conversations my parents had with their friends at the coffee hour, but I was content goofing around with my friends and munching on the doughnuts that were omnipresent at church. If the church where I grew up had a taste, it would be just like old-fashioned glazed doughnuts—sweet and warm.

From time to time, an adult would say, "Your father and I may not see eye to eye on everything, but I appreciate him just the same." After that lady told me how hilarious she thought my mom's Halloween costume was, I wasn't sure if I should tell my mom, because there was something in the tone of the comment that sounded a little insulting.

Of course, I'd already seen the costume. One night, around Halloween of that year, my parents burst into our living room, lined up in front of me and my two brothers, and said, "Ta-da!" It wasn't much of a surprise to see my dad dressed up as a football player, wearing a red numbered jersey and helmet, because this

was his secret fantasy, but my mom's costume was shocking. She was wearing a pair of serious-looking horn-rimmed glasses, with black pants, black shoes, and my dad's black clergy shirt, with a white clerical collar. She seemed proud of herself as she showed off her priest costume, putting her hands together in a prayer position and looking up as if she was talking to God.

One evening while we were sitting at the dinner table, my dad and brother got into a conversation about the ordination of women. Thomas, who was fifteen at the time, already had a lot of interest in the church, though I'm not sure he knew yet that he would eventually become a priest. The conflict over women's ordination was boiling over in the Episcopal Church, with the 1970 General Convention narrowly voting against the ordination of women. My parents shielded me from a lot of the ugly talk because it became deeply personal when our close friends in the church formed camps on opposite sides of the issue, creating a lot of hurt feelings.

"Why can't women become priests?" I asked, feeling insulted at the thought that anyone would think such a thing. My dad said, "Some people believe women can't get ordained because Jesus chose men to be his disciples." My brother quickly replied, "But Jesus only chose Jews too, and the church ordains non-Jews. If the Episcopal Church ordains those people, then why not women?" With a professorial tone of voice, my dad responded, "Especially since there were women, like Mary Magdalene, who were some of Jesus's closest followers. After the resurrection, Jesus appeared first to Mary Magdalene and then he asked her to announce the good news to the others. Some people call her 'the apostle to the apostles.' But the opponents of women's ordination say that women are unordainable."

At seven years old, I didn't fully understand what that crushing word meant, "unordainable," but I did know some people I cared about and respected didn't think women were as worthy as men. This went against everything I had been taught about how much God loved all people equally. My Sunday school teachers told me I was a child of God, created in the image of God to carry out God's work in the world. Why couldn't I do that as a priest?

If my mom was alive today, I would ask her why she chose to dress up as a priest that Halloween. Did she secretly wish she could get ordained? Did my mom feel called by God to a priestly vocation? Or did she think it was funny to dress up as a priest because it was so absurd, so unimaginable? What about that lady who wanted to tell me she thought my mom's costume was hilarious? I wonder if she thought it was ridiculous for a woman to dress up as a man. Or was she tickled on some deep level to see the image of a women priest for the very first time? I'd like to think the other women at the party got some satisfaction out of seeing my mom dressed up as a priest.

My mother came into her adulthood in the 1950s and she was raising a family during the 60s. The feminist movement informed her views of the ordination of women. Since my parents' church friends were taking opposing sides on this issue and there was conflict, I'm guessing she was uncomfortable saying what she really thought. Maybe dressing up as a priest was her way of declaring where she stood on the issue. I wonder if my mom's friends thought she was being provocative, or did they admire her courage for daring to break through a taboo by wearing a man's uniform?

Maybe my mom chose to dress up as a priest because she thought it was silly for everyone to get so stressed about who could and couldn't be a priest. Perhaps she thought everyone was taking priesthood, and themselves, a little too seriously. I could see her using that costume to subtly mock those who would elevate priesthood above other vocational callings from God. I bet she thought her vocations as a mother and medical assistant, working for an eye doctor, were just as important, if not more important, than my father's vocation as a priest.

During those years in Dallas, my mom never got the opportunity to see a real live woman priest. But she was able to incarnate what that experience might have been like for the rest of the people who were at that costume party. I wonder if the image she presented as a pretend priest made people feel more comfortable with the idea of women's ordination. For me, it was a huge turning point in my life when, in 1987, I moved to California and

experienced a woman priest for the first time. I remember that day when I watched a woman preach and lead worship; I started to shake. Seeing her in priestly vestments made me feel that some sort of healing was taking place deep inside me.

Growing up, one of my favorite hymns was "I Sing a Song of the Saints of God," which is about the many ways God calls people to be saints in the world, through all of their occupations, circumstances, and work. At school chapel, I remember belting out the final verse, "You can meet them in school, or in lanes, or at tea, in church, or in trains, or in shops, or at tea, for the saints of God are just folk like me, and I mean to be one too."

My mom died years before I discerned my calling to become an Episcopal priest. If she saw me today, wearing a black clergy shirt, white clerical collar, and heels, I bet she would laugh until she cried.

Reflection Questions

- In your lifetime, how have gender roles and expectations changed? What breakthroughs have made a difference to you?

- Have you ever considered that God might be calling you to a particular role, activity, or work?

Holy Hospitality, Solidarity, and Accompaniment

Someone shares bad news, or you see people going through a difficult time, and you try to think of something you can do or say that would make a difference. Doctors and nurses prescribe treatments to alleviate symptoms and provide cures. Firefighters and paramedics do heroic things like rescuing people and rushing them to the hospital. But most of us don't have these skills, so in the face of other people's tragedies, we struggle to find ways to help, even though our hearts are in the right place. It took going all the way to El Salvador, learning about solidarity from the people there, and getting dengue fever for me to learn some new ways to care for others when they're suffering.

My friend Jennifer invited me to go on a trip to El Salvador with her and a group of Episcopalians from her diocese, and I said yes mostly because I thought it would be fun to go on an adventure. The Diocese of Central New York and the Diocese of El Salvador had a "companion relationship," with the purpose of fostering friendships, mutual understanding, and global partnerships in ministry. At the retreat center in San Salvador, we heard an orientation talk, and I can only recall two things that were said: "We hope your time with us will help you gain a deeper understanding of social justice work and solidarity," and "Be sure to wear mosquito repellant."

Early one morning, a white van picked us up, and the young driver, who wore a silver cross around his neck, talked about the "base community" we would be visiting that day. The person sitting next to me in the back seat pointed to the gun our driver was keeping on the dashboard in the front of the van; apparently our driver was also our tour guide and bodyguard. Along the way, we stopped for the driver to show us the place where a battle in the Salvadoran

Civil War had taken place. He pointed to bullet holes in the side of an old shack, and described that the people living in the rural base community moved there after the men and boys in their families were killed. Base communities like this one developed in Latin America out of a need for people living with injustice and poverty to support each other, often over and against the ruling elites, who were enmeshed with the wealthy leadership in the Roman Catholic Church. Under an oppressive regime, poor people banded together in base communities to practice their Christian faith through the sharing of resources, Bible study, and worship.

When we arrived, people (mostly women and children) came streaming out of their homes to greet us. Most of the houses in the base community had no doors; they were simple dwellings with beads and curtains hanging in the doorways and windows. Our driver seemed to know everyone, and as he introduced us, he told each person's story about the fathers, husbands, sons, brothers, and uncles who had died in the civil war, and how many had lost their homes and been injured.

One elderly woman motioned for us to follow her. The driver said, "Please understand this is the very best hospitality she has to offer us today." Most of the homes had no electricity, and yet in the center of the community we came upon a shed that housed an old-fashioned Coca Cola cooler plugged into an electrical outlet. The woman stopped at the cooler, and with a look of pride on her face, she opened the cooler and handed each of us an ice-cold bottle of Coke. It was exactly what we needed after the long drive on a hot day, and we understood this was a generous gift.

After a walking tour of the community and outdoor chapel, each of us was dropped off, in groups of two or three, to have lunch with people in their homes. The lady who welcomed us into her humble home, with dirt floors and just a few rooms, invited us to sit down in her kitchen while she made lunch for us. She showed us how she was hand-making fresh tortillas, and just as she was cooking them, a chicken wandered into the kitchen and jumped up onto the counter where she was preparing food. Laughing and gently sweeping the chicken aside, she filled tortillas with

beans and rice, and handed them to each of us. We were invited to join a Bible study, even though most of us didn't understand Spanish. Still, people shared in Spanish, and we listened as our translator did his best to keep up. These people mostly worked on nearby farms, harvesting crops, and many got sick at some point with dengue fever, which causes extreme pain, and yet they had to continue working to support their families. It was obvious that these people were faithful and supportive of each other, and they expressed a joy that was surprising. Whatever they lacked in material resources was made up for in the happiness that comes from living in a community where everyone is in it together, no one has more than any other member, and everyone is committed to living an authentically Christian way of life.

That night, we were invited to dinner at another woman's home, where our whole group sat outside at a long table, watching the sunset overlooking a little valley. Those of us who visited the base community that day were sharing stories about our experiences when some chickens appeared and started pecking the ground near our table. Our host brought out platters and bowls of food, and before she offered a blessing, she announced something that made the Spanish-speaking people in our group laugh. They translated what she said: "She wants to welcome us to her home, and she's especially proud that the chicken she's serving us tonight comes from the chickens that live on the patio. Instead of eating grain, these chickens eat bugs, and it makes them much more delicious." We laughed about eating "pollo de patio," which really was wonderful. Tears welled up in my eyes, as it became obvious that our host was treating us as her honored guests.

That night, I took a shower to wash off the sweat of the day and the bug spray I had so religiously applied since being warned about the disease-carrying mosquitoes. Lying in bed and processing all I had experienced, a feeling of confusion swept over me. I thought the purpose of our trip to El Salvador was to help the people there who were being treated so unjustly. People shared stories of unspeakable suffering and injustice, and many were living in poverty. Why weren't we doing more to help? It was frustrating

to realize I couldn't think of what we could do, given that we only had a week there, and we had little power to create lasting change in a foreign country. And why were these people being so generous to us when we should be the ones being generous to them? I began to see that they were teaching us some important lessons, and in turn they were benefitting from us being there as we listened to their stories and acknowledged their suffering.

At breakfast on Sunday morning, an announcement was made that each of us would be picked up and driven to a different church to experience their worship. The church I was visiting that day was out in the countryside, and it consisted of a cement slab floor, covered by a corrugated metal roof, with open walls. The priest spoke some English and was eager to tell us about the people in his congregation, most of whom were involved in farming.

As the band was warming up and people started arriving, the priest handed me a Bible and invited me to read the gospel at the service. I felt embarrassed as I said, "I'm so sorry, but I don't speak Spanish." I don't remember exactly what he replied, but the message I understood was that it didn't matter to the people of this congregation if my Spanish was not good. It would give them joy to include me in their worship. So, would I please honor them by doing the reading? I understood this congregation wanted to welcome me as a stranger in their midst, and that it would be rude of me to be more concerned about my performance than to join them in their worship. When the time in their church service came for me to proclaim the gospel, the priest gestured for me to begin reading, and I awkwardly sounded out each syllable of the Spanish words on the page. I looked up to see people smiling at me, and I felt humbled by their generosity. I couldn't speak their language, and still they were so accepting of me.

Back at the retreat center, local church leaders gave talks about the development of liberation theology in Latin America during the 1960s. This was a movement that sought the liberation of people who were suffering from oppression and poverty. The bishop shared stories of Christian leaders like Archbishop Oscar Romero and others who were assassinated after advocating for the poor and

publicly speaking out against social injustice and violence. One of our hosts said something like, "We want you to know it makes a difference for you to come all this way to listen to our stories and break bread with us. When we share mutually in each other's suffering, and we work for liberation, this is solidarity. None of us can be fully liberated until we are all liberated from the power structures that oppress our people. Through our solidarity, we enter into the suffering of Jesus on the cross, knowing that God sent Jesus to liberate us all. You are witnesses to our suffering and now you have stories to share when you get back home. We ask you to pray for our liberation and we will continue to pray for your liberation." At the end of our closing prayers, Bishop Barahona gave each of us a gift of a wooden egg, wrapped in tissue paper, to remind us of the Easter hope for transformation and new life.

A week after I got home, I developed a fever and terrible pain in my bones. After consulting a tropical disease specialist, I was diagnosed with dengue fever, which is contracted through the bite of an infected mosquito. Every morning that I was in El Salvador, I sprayed bug repellant from head to toe, but I didn't want to sleep with the chemicals on my skin, so at night I rinsed it all off in the shower, thinking I would be safe in my room. Apparently, that's when the bug got me. Dengue fever is a viral disease that is sometimes called "break-bone fever" because it causes a person to feel extreme pain deep inside their bones. It was the sickest I've ever been, and the symptoms lasted for several months. The fever would come and go, and I sought treatments to find relief, like acupuncture, bitter-tasting herbal teas, and lymphatic drainage massage. As I lay in bed, sometimes with a fever, I had a lot of time to think about what I'd learned on my trip.

I had set out to better understand what it was like for the people of El Salvador; their struggles, their way of life, their needs. And I came home with dengue fever, the same illness afflicting so many of the poor people living in rural areas where standing water collects in old tires and puddles, thus creating a breeding ground for mosquitos. I started to see that the pain I was feeling was the same

pain so many Salvadorans felt, and that through our mutual suffering, we were experiencing something akin to solidarity.

When I was working as a hospital chaplain, my supervisor, the Reverend Sandy Yarlott, said, "Whenever I visit people in the hospital, I try to practice solidarity as I listen and attend to their suffering. One important aspect of solidarity is accompaniment. I try not to offer advice, unless people ask for it, and I focus on not pushing from behind or pulling them along by getting ahead of them. Instead, I try to walk side by side with them, accompanying them, matching my pace to theirs, and trying to stay focused on exactly where they are and what they are experiencing. This kind of care really makes a difference in people's lives, especially when they're suffering."

While I was sick, my parents, brothers, and in-laws called and sent flowers. Since we lived in the rectory of the church where my husband was the priest, he was able to come home several times a day to check on me. My friends Julie, Tom, and Jennifer stopped by regularly to visit, sometimes bringing lunch, and friends like Amy and Mary called and sent cards. A parishioner who was a nurse brought over articles about dengue fever. Professors and classmates from my seminary community checked in from time to time, just to let me know they cared. Loved ones listened as I talked about the pain I was in, which helped me feel less lonely. As people accompanied me through my illness, I experienced this as a kind of solidarity; and it made a huge difference, lessening the pain I felt.

After feeling sick on and off for eight months, I finally felt well again. So, I invited all my friends to a "No More Dengue Fever Party!" in my backyard. The fajitas were spicy, the sangria tasted sweet, and my friends and family laughed late into the night, celebrating life.

Ever since then, this deep learning about hospitality, solidarity, and accompaniment has guided the ways I practice caring for people. It's tempting to want to give helpful advice or suggest ways a person might do things differently, and it would be satisfying to solve other people's problems. While there are times when

people ask for practical help, most of the time, there's nothing I can really do except go back to practicing solidarity and accompaniment. So, I show up, listen, let people know I've understood their story by summarizing it back to them, provide gracious hospitality when I can, and try to stay in step with people, not pushing or pulling them, but walking side by side. In these moments, I am reminded that the resurrected Christ walks with us, just like he accompanied the two disciples who were grieving as they walked down the road to Emmaus.

Reflection Questions

- Remember a time when you experienced generous hospitality. What was that like for you?

- Can you recall someone walking side by side with you through a difficult time in your life? What difference did that accompaniment make for you?

Appearances

As a newly ordained priest, I was surprised by the things people felt comfortable saying as they shook my hand in the receiving line after church. "I've never seen a priest with painted fingernails." "There's something about your hair that looks different." "Your earrings were distracting me today." At gatherings with other women clergy, I heard similar stories about the awkward comments they'd heard about their bodies, clothing, and appearance. I came to understand this was a pattern I would have to manage as a woman priest. After I got ordained, it was as if people felt the need to let me know they were having a hard time figuring out how to relate to someone (me) who didn't look like all the other priests they had known before. For many, I was the first woman priest they had ever met.

In the early years after he was ordained priest, my husband, Mark, heard repeated comments like, "You're too young to be a priest." But while Mark occasionally heard comments about his appearance, those comments tended to be less inappropriate than those that women priests are subjected to. One colleague theorized that congregations may feel ownership of their clergy, even their bodies, which sometimes leads parishioners to make comments that are overly personal.

Maybe some people feel more comfortable crossing boundaries because we live in a culture where women's bodies and clothing are constantly being held to unrealistic beauty standards. Teenage girls are influenced by fashion magazines with photoshopped and airbrushed images of women on the covers. The beauty industry works hard to convince women that they are "less than" because they know this will motivate women to buy whatever it is they are selling. Marketing is often aimed at helping women find ways to correct or conceal their many "flaws."

One colleague shared that on the first day of her hospital chaplaincy training program, the supervisor told her to "dress less sexy, and more subdued" due to the boots and floral print she was wearing that day. It's hard to imagine boots being too sexy for ministry, or that anyone lying in a hospital bed would reject the ministry of a chaplain wearing bright colors. In seminary, I remember a lot of talk about the need to wear black shoes, always with a closed toe, and small earrings, preferably pearl studs. In some religious traditions, women are encouraged to dress modestly to avoid attracting any sexual attention from men. The robes that clergy wear in church, and the black shirts and white clergy collars, go a long way toward making women appear shapeless and covered up.

At one of my first congregations, a woman walked up after church with a worried look on her face, and said, "I need to speak with you about how we are going to deal with your speech impediment." When I said, "Please tell me what you mean," she replied, "Your voice is simply too high and that makes it hard for me to hear you when you speak in church." After checking in with my rector and fellow staff, I felt reassured that they did not detect any speech defect, nor was it hard to hear me, and in fact they said, "The problem is not that your voice is too high; the problem is that she's not used to hearing a woman's voice leading worship." After that, I made sure to increase the volume on my microphone, but I also was intentional about spending time with this lady. Working on ministry projects together, we became friends, and she never said another thing about my voice. Over the years, I have become aware of the extra energy it takes to win people over, sometimes having to prove I'm a real priest.

There have been times when I've wrestled with imposter syndrome, as it has often been a challenge to earn the same respect that's been more easily granted to my male clergy colleagues. I married Mark when he was in seminary, and I saw how quick people were to show him respect as a priest and leader. I've heard women clergy talk about struggling with imposter syndrome to the point that some have not applied for the best jobs because they assumed they wouldn't be seriously considered. When I was

in my twenties, I remember my female clergy colleagues talking about how expensive it was to buy what we called our "suits of armor," feeling that if we just wore the right clothing, then we would be taken more seriously.

In the years I've been interviewing ordination applicants for the Commission on Ministry, I have rarely, if ever, heard a man say he couldn't imagine that God would call him to be a priest or deacon, but I've heard countless women say this. The church's history of refusing to ordain women has resulted in a lot of women never feeling worthy enough to step forward to answer God's call. What a shame for the church that we have not benefitted from the ordained ministries of countless women, especially when God has been calling women all along.

When I was in seminary, I made a commitment that whenever a Scripture passage was assigned that described female spiritual leaders in the early Christian movement, I would focus my sermons on them. Growing up in the Episcopal Church, I never once heard the New Testament stories about women spiritual leaders like Lydia, Priscilla, Junia, Euodia, Syntyche, Phoebe, Nympha, and Chloe. When I did hear stories about women in the New Testament, it was mostly about the Virgin Mary being obedient and giving birth to Jesus, or about Mary Magdalene, who was mistakenly identified as a prostitute. In a seminary course on church history, I learned that on September 14, 1591, Pope Gregory the Great gave a homily asserting that Mary Magdalene was the same person as Luke's unnamed sinner, and also Mary of Bethany. Getting the multiple women mixed up, Gregory pronounced that Mary Magdalene was also the one described as the prostitute, thus giving her a false identity and erasing her role as the first person to be greeted by the resurrected Jesus, as well as the first to proclaim that good news. It is easy to see why some feminist theologians have asserted that Mary Magdalene's role and reputation were deliberately altered to suppress women's leadership in the church.

When little girls grow up never learning the biblical stories about women spiritual leaders, and they never see a woman priest, they are less likely to consider that they might be called to serve as

clergy. When little girls grow up hearing God being referred to as "Father," and they hear male priests being referred to as "Father," they get the idea that to be a priest, a person should be male. No wonder so many women in ordained ministry still struggle with imposter syndrome. I'm guessing this is often the case for other women professionals who are doing a "man's job."

Since women were officially ordained in the Episcopal Church in 1976, it makes me sad to hear from younger women clergy that people are still making inappropriate comments about their appearance. I've heard stories about older male and female clergy, and seminary professors, who instructed women clergy about what they should wear, and how they should present themselves, including what shoes and earrings to wear, and even what name to use, saying this would help them in their ministries. Some younger women priests have shared that this advice ended up backfiring by making them feel even more self-conscious and even less confident in their own calling.

I was a young adult when I saw a woman priest for the first time. She processed into the church wearing priestly vestments, then began leading worship. I saw how natural it was for her to function as a priest. She was beautiful because she was uniquely herself, appearing confident in her own worthiness as a beloved child of God. She was powerful because she expressed an authentic passion for proclaiming God's love. I took her seriously as a priest, not because of the clothes she was wearing, or how she styled her hair, but because of the way she made me feel about myself, excited that I too am cherished by God and am worthy to proclaim the good news of Christ.

Reflection Questions

- What do holy people look like? Have you ever considered that you are holy?

- What impact has it made on you to have the presence or absence of female spiritual leaders, either in the church or in the Bible?

Rescued and Claimed

When I was thirty-five years old, after leaving my first job as a priest because of a high-risk pregnancy, and finally giving birth to twins, I fell into a year of postpartum depression, and started going to counseling. Casting about for suggestions to help me feel better, my therapist said, "One thing you may want to try is doing research about your adoption. It's common for adoptees to have children and then begin yearning to know more about their own background."

Growing up, whenever questions about my adoption popped into my mind, I pushed them aside, worried that pondering these questions would be a betrayal of my adopted family. So, the first time I gave myself permission to explore my adoption was when a seminary professor asked us to write an essay describing our birth story. His theory was that the story a person is told about their birth makes a permanent imprint on them, thus influencing who they will become later in life. Wrestling with that topic, I envied those who had a story to tell about their birth.

Every time I went to a new doctor, it pained me to say, "I was adopted, so I don't have a medical history." My parents talked about my adoption casually. "We always wanted a baby girl, and after your brothers were born, and we lost two daughters, the doctor told Mommy she couldn't have any more children. When you were four days old, we brought you home to live with us, and decided to name you Mary Louise, after our other daughters, Mary Kay and Diane Louise, who passed away when they were babies." That was enough to satisfy my curiosity, but there were times when I wondered, "Who took care of me those first four days, and why did my birth mother give me away?" My fantasy was that my beautiful birth mother and handsome birth father were teenagers who were madly in love, but when my mother found out she was pregnant, her parents forced her to give me up for adoption.

When I finally gathered up the courage to call the adoption agency in Houston, the first person who answered the phone said, in a thick Texas accent, "Honey, I'm sad to say it's against the law for me to tell you the facts about your adoption. It was a closed adoption, and the law says you don't have a right to know what happened. Back in the sixties, people thought this was the best thing, but to be honest, I've never really felt OK with that." The social worker paused to take a deep breath before saying, "Sweetie, my name is Charlene. I'm dying of cancer, and I don't have long to live, so I'm gonna break the law and tell you everything. Wait just a minute while I find your file."

The pounding in my head was so loud I could barely hear what she was saying. It was the moment I longed for, even though I feared it, and I wasn't sure I wanted to hear any more. What if my birth mother was a victim of rape or incest? What if she was a drug addict? What ifs like these were making my heart race as I sat there with the phone to my ear.

I waited on hold for what seemed like forever, until Charlene the social worker got back on the phone and said,

"I finally found your file, and I see that in 1964 I was the one who interviewed your birth mother and father when they came into the agency, a week before you were born. Your mother was thirty-one, had light brown hair, was attractively dressed, and said her parents were Polish immigrants. Your father was wearing a suit that day and was of Irish descent. They were married in New Jersey more than ten years prior, but they didn't have other children. Your father served in the military and was injured in the war, so he had back problems leaving him unable to work. Your mother worked as a nursing assistant at a local hospital so she could support the two of them. They didn't feel like they could take care of you, given that your father was disabled and your mother was working full-time. She had planned to keep you until the last few weeks of her pregnancy when things got worse at home. I had the impression that your father drank a lot. A week before you were born, your parents came to my agency and filled out the papers.

"You were born in the same hospital where your mother worked, and the deal was that we'd pretend she and your father were going to take you home. Those of us who were with the adoption agency pretended we were visiting a friend with a new baby. That was awkward because people at the hospital knew your mother and kept stopping by to say congratulations. Your mother took care of you those first four days, holding you nonstop. When it was time to leave the hospital, your mother cried as she dressed you in a little outfit she received as a gift. Your father brought around his car, and we drove together to the adoption agency, where your mom placed you in my arms, leaving me to give you to your new parents that afternoon.

"From time to time, I would bump into your mother at the hospital; we were supposed to act like we didn't know each other. But one time, she came up and asked if everything turned out alright. I reassured her that you had been placed with a lovely family, an Episcopal priest and his wife who already had two sons, and who desperately wanted a daughter."

About six months after that phone call, when Charlene told me everything, including the names and physical characteristics of all my aunts and uncles, I called the agency to ask a few more questions. The person who answered the phone said, "I'm afraid Charlene recently passed away from cancer; we will miss her and her generous spirit, God rest her soul."

Hanging up the phone, I started to weep.

Then I cried big ugly tears.

I wailed for all of it—for Charlene's kindness, for babies like me being lost and found, for couples who yearned to have a child, for children feeling abandoned, for the cruelty of war and chronic pain, and for the sadness of alcoholism. Mostly, I cried from a deep sense of gratitude that people looked out for me all along, and I can only conclude that God was working through them to rescue me!

In the box of precious things my mom gave me before she died was the yellowed worship service leaflet from the day when my family and godparents gathered for my baptism, at St. Alban's Church, where my dad served as a priest. It was important to my

parents that I would grow up knowing I belonged to God's family; that I had a tribe to be part of in the Episcopal Church. I'm so grateful I got to grow up in a church where people taught me that God loves all people and adopts them through grace.

Every time I baptize someone into the faith community, pouring water on their head, anointing them with oil, and making the sign of the cross on their forehead, I look into their eyes and say the traditional words, "You are sealed with the Holy Spirit and marked as Christ's own forever." These profound words proclaim the reality that every person in this world is a beloved child of God, created in the image of God, and claimed as God's own through birth, adoption, and grace.

Reflection Questions

- What groups of people have claimed you as their own and made you feel like you belong?

- Looking back, can you think of people who helped or rescued you from a difficult situation? Might God have been working through them?

Ministry with a Baby on Each Hip

Sitting face to face with a trusted mentor, I shared the news, "Mark and I just found out I'm pregnant with twins!" "Wow!" he said, "It looks like from here on out, you'll have a congregation of two."

My face turned red as I left that conversation, got in my car, and burst into tears. How could he say such a thing to me, and why would he imply that having twins would prevent me from functioning as a proper priest in a congregation? And why would someone assume that because of having twins my priesthood would be wrecked, while Mark's career as a priest would still be a success?

I had carefully planned out my pregnancy by waiting until after I had finished earning my seminary degree and had been ordained and working in a parish for a year. Having children was the next big step for me and my husband, Mark, and even though we learned we would have to overcome some infertility issues, we were excited about beginning the adventure of raising children together.

In my fantasy, I would be very pregnant and working at my office desk when I would feel a twinge, and after going to the hospital and giving birth, I would go back to work in just a few weeks. But because of the twin pregnancy, I ended up having preterm labor problems, which meant I had to quit my job and go on bed rest, which lasted for a total of twenty-six weeks. Mark and a dear friend packed up my office at the church, brought all my books and files home, and there I spent the rest of my pregnancy lying on my back, talking on the phone, watching episodes of BBC's *Pride and Prejudice*, trying not to give birth, and worrying about what the future might hold, both for my family and my career as a priest. With Mark's steadfast support, we made it to thirty-six weeks, and I gave birth to two healthy babies, whom we named Hannah and Jack.

The early days of parenthood were full of love, though they were not easy, even as Mark took a sabbatical to stay home and care for the twins, and friends and family did the best they could to support us. I remember being so sleep deprived that I could barely function, and what I yearned for the most was a nap. But after about eight months, I got a call from a priest who invited me to serve part-time at his church so he could take a three-month sabbatical. I'll always be grateful to that colleague for helping me get back into parish ministry, and for having confidence in me, even though I had baby drool and breast milk on my shirt much of the time.

Generously, my dad and stepmother paid for a nanny to come to our house to care for the twins on Sundays plus one other day a week. Working at a local church, I noticed that parents, especially, were seeking me out for pastoral care conversations and counseling. My ministry happened at play dates in people's living rooms with babies rolling around on the floor and parents sitting in a circle drinking coffee and commiserating about their lives. Having children gave me special access and the opportunity to be in solidarity with other parents. Being a working mother helped me understand the reality of juggling a career, kids, and family. It was a relief to learn I was not alone in my struggles, and at the same time, I found that I had something new and helpful to offer other parents.

There were grace-filled moments when we laughed together about going from being up-and-coming young professionals in our careers to being sweats-pants-wearing moms and dads who were taking care of children and wiping noses without any praise for being successful. After all, babies bring a lot of joy, though they tend to be rather demanding bosses, and they are not very good at offering recognition for a job well done. We patted each other on the back in jest and said, "Good job! You deserve a raise and a promotion for getting your baby on a good nap schedule and for successfully weaning them off pacifiers!"

I hosted forums and small group gatherings so people could have meaningful conversations about parenting, as well as reflecting on the ways God was showing up in people's everyday lives. The stories and insights I heard in these conversations served as

rich content for my Sunday sermons, because everyone, regardless of their family status, yearns to experience God, and can benefit from the invitation to see the holy in their daily lives, at work, while cleaning the house, at the grocery store, and in the midst of time spent with friends.

Anyone who has taken a toddler on a walk knows the joy of holding a tiny hand and stopping every few steps to delight in every little dandelion, doodle bug, and doggy on the path. Hannah and Jack invited me to sit on the floor with them for hours, building with Legos, doing puzzles, and playing with trains. I started enjoying balloons, bubbles, and bath toys in a whole new way, and we decided it was cool that God created things that float. My kids loved it when we turned up the music and danced around the house, taking joy in moving our bodies to the beat. The twins taught me how to be more present to creation, giving thanks to God for even the tiniest wonders, like ants, pebbles, sticks, and autumn leaves. Together, we thanked God for every little thing we enjoyed, and that became a spiritual practice for me, leading to a greater sense of gratitude for all the blessings in life.

During the thirteen years that my twins attended St. Paul's School, I waited in the carpool line on school days, and learned to practice breath prayer, saying "God in me" as I inhaled and "me in God" as I exhaled. This breath prayer helped me feel more centered before the twins jumped in the car and started chattering away about their day. I created a playlist of music that inspired me so I could pray while waiting in the car, sometimes endlessly, for them to be finished with soccer practice, dance class, tennis lessons, cross-country running, and the list goes on. At sporting events, I tried to intentionally notice and give thanks to God for the children, for their athletic abilities, and for the love parents showed through their cheering. While I grew up mostly thinking God resided in churches ("God's house"), I started seeing holiness all around me, mostly due to the excellent teachers I had in Hannah and Jack.

It turns out that having my congregation of two ended up making me a more spiritual person and a better priest.

Reflection Questions

- In the midst of your daily life, while taking care of family, doing chores, and working, can you think of ways that you have experienced God's grace?

- Other than in church, where are some places where you are most likely to feel the presence of God?

God Moments

M y guess is that most of the time, God is showing up in my life and I'm too distracted to notice. Even when I have an intuition that God is reaching out to me, I'm likely to discount these experiences because, after all, there are coincidences and synchronicities in life that have nothing to do with God. The definition of grace is that it is a gift from God that is undeserved and unearned. It's hard to recognize God's grace in the moment, and most of the time, I can only see grace while looking back on my life. Sometimes it's easier to see God at work in other people's lives than to see God reaching out to me personally. I walk through life feeling held in God's embrace, and I trust that Jesus is walking with me, but I'm not someone who has a lot of spiritual mountaintop experiences. So, it really gets my attention when I notice God ministering to me through people and events.

When my older brother, David, died suddenly at the age of sixty-three, I felt shocked and heart broken, yet I still had to go through the terrible business of notifying people and making plans. Weighed down by grief, it was hard to imagine what David would want us to do to honor him. He wasn't a churchgoer, and he had problems with organized religion, perhaps because so many members of our family (seven at one point) were ordained ministers. So, I doubted David would appreciate us having a church funeral for him, and I decided he might prefer we simply go out to a Mexican restaurant, drink margaritas, and make a toast in his honor. On the question of what to do with David's ashes, the bright idea I pitched to my brother, stepmom, and sister-in-law was to go to David's favorite golf course and drop his ashes in the pond. I really didn't want to plan an event that would irritate David—even though funerals are really for the living—and the resulting angst from not knowing what to do gave me a terrible headache.

That night, as I was reading in bed, an old friend of David's contacted me, saying he had seen the announcement on Facebook and wanted to offer his help. On the phone, he introduced himself as Mike and reminded me that when we were kids, he and David used to run in and out of our house all the time. He told funny stories about the day when my mom caught him and David smoking, and the moment when David dropped his trumpet on the floor, damaging the bell of the horn. Mike said the two of them kept up their friendship through the years, and from time to time, David would show up on his front doorstep and ring the bell, and Mike and his wife would invite him to stay for dinner. They used to spend time sitting by the pool, drinking beer, and having deep conversations about life.

I described my plan about the Mexican restaurant and golf course to Mike, then asked if he thought David would approve. "You know, David had a connection with God," Mike responded. "He probably wouldn't tell you about his faith, because you were just his little sister. But he kept in touch with old friends at church, and he loved the folks he grew up with at camp, and even though he had problems with religion, he still felt like he belonged to a community. I really think he would want to have a funeral." "You don't think it would make David angry for us to have his funeral in a church?" I asked. "I think that's what he'd want!" he replied.

After thanking Mike, I got Diana, Thomas, and Jane on the phone to fill them in, and as I shared the funny stories Mike told me, my headache lifted and the deep angst I was feeling melted away. "I really think this was a God moment, and that God used Mike to reach out to me, and to our family," I said, "both to give us the comfort of knowing David had a spiritual life, and to give us clarity about where to have David's funeral."

Falling asleep that night, I felt so relieved. The next day, I was thinking about why it made such a difference to hear Mike say that David talked about his relationship with God. Why did that matter so much to me? It's not like I think people need to proclaim their faith a certain way, or do good deeds, to earn their ticket into heaven.

I'm happy David talked about his relationships with God and old friends from church, because I'm sure that sense of belonging enhanced his life. David was claimed by God, even though he may not have been aware of it; feeling claimed by his old friends must have made a difference. If my brother had ever thought our family would be worried about his soul because he didn't go to church, or say the prescribed words about his faith, that was not the case at all. Maybe I should have told him what I really thought: that he was a beloved child of God who was cherished and forgiven, that he belonged to God no matter what, and that nothing could ever separate him from the love of God, even death. Because of God's grace, David was forgiven and loved, and that love never ends.

I remember reading somewhere that most preachers only have one sermon, which they preach again and again, and after being ordained for twenty-five years, I'm convinced that's often true. Any member of my church would recognize that I preach a lot of sermons assuring them that every human being is a beloved child of God who was created in the image of God, and that God loves them unconditionally. Countless times, I've preached, "In our church, we cherish people, so they'll know they are cherished by God!" God loves every human being, not because of how good they are, but because of how good God is!

If God is love, and God loves us throughout our lives, then when we die, God is not going to abandon us, no matter how many mistakes we've made. Even as Jesus was dying on the cross, he turned to the thief being crucified next to him and said, "Truly I tell you, today you will be with me in paradise" (Luke 23:43). If Jesus did not hold that thief's sins against him, and he was anticipating being with him in paradise, then why would we think that God holds people's sins against them, excluding them from heaven? God's love transcends our human weaknesses. Recognizing that we don't deserve it, because human beings are a mess, really, we have a lot to celebrate. So, we fall on our knees to worship and thank God because we're so grateful for God's compassion, forgiveness, and mercy.

I share this story of a time when God showed up for me and my family because I hope you will notice, name, and share the God moments in your own life. Go searching for grace in the rearview mirror, looking back on your life, and when you find it—those times when you discover so much meaning, comfort, and inspiration that it gives you chills—thank God for cherishing and loving you!

Reflection Questions

- Can you think of any experiences in your life that might have been God moments?

- What was that like, and what were the clues that God was reaching out to you?

- What do you believe about God's love never ending, even beyond the threshold of death?

Chapter 3

Samantha Vincent-Alexander

Angels in the Dive Bar

I laughed out loud the first time I ever tried on a clergy shirt with a clerical collar. It was the summer after my first year at a Presbyterian seminary. I was a Roman Catholic woman interning in an Episcopal church wearing a clerical collar. Laughter was the only response. My supervisor for the summer was a female priest who had been ordained in the late 1970s. She was determined that I have the full experience and lent me her old clergy shirts and collars. A seminarian's collar has a vertical stripe on the front. I used a small piece of electrical tape. At the time it seemed ludicrous to be wearing any kind of clerical collar, but it was transformational for a twenty-four-year-old Roman Catholic woman. It showed me what I could become.

I felt like an imposter at the time and in many ways I was one. Most people cannot tell the difference between a seminarian's collar and a regular one, so many assumed I was a really young priest, or a nun, depending on what denomination they were most familiar with. Two years later I became an Episcopalian and entered the ordination process. Two years after that, at the age of twenty-eight, I was ordained. When I put the collar on that time, there was no electrical tape. I didn't laugh, but I still felt like an imposter and was certain other people were laughing. I only caught someone laughing once, but there's still time.

When you are a woman priest wearing a clerical collar, you get used to getting a lot of weird looks and even weirder questions.

The common assumption is that you are a nun, and you can assume at least three things about that person. 1. They have never seen a nun in person. 2. They saw one on TV and didn't look very carefully. 3. They were baptized Roman Catholic but haven't attended since childhood. Once you explain to someone that you are a pastor, they usually remain confused. If the person is a Christian, they probably have never met a woman pastor and attend a church that doesn't allow the ordination of women. This person will either start asking questions ("What do I call you?") or walk away with a shake of the head. Sometimes the Christian will be excited to meet a woman pastor, and those interactions always make the others bearable. My favorite interactions are the ones where someone notices my fun shoes and then my collar. This combination of faith and fashion pretty much makes my day.

Since I have been ordained sixteen years now, I am fairly accustomed to these looks or conversations. Oftentimes I even forget I am wearing a clergy collar. Yet when I see how my husband is perceived in a collar, I am reminded of how far women have to go. He will occasionally get the second glance. But I have never seen someone look at him with confusion or amusement. Most people assume that he is a Catholic priest and I know he has gotten out of traffic tickets because of the collar. (I have only gotten pulled over once in a collar, for a missing registration sticker. The police officer started giggling when he saw me. A grown man giggling. Why? Because he thought he had just pulled over a nun. When he realized I was not a nun, he assumed I was just wearing a weird shirt.) No one ever asks my husband what they should call him. They usually call him "Father" and that works for him. A surprising amount of people try to call me "Father" because they think this is novel and witty. It's not.

While my husband never gets weird looks or comments while wearing a clergy collar, he also has never been mistaken for an angel. I have. I normally don't walk into a biker bar with a collar on. I don't frequent biker bars. However, this one had good barbeque and I needed to bring something to a church dinner I was attending. As soon as I walked into the bar, I noticed a group of women at

the end of the bar. They turned around and as soon as their eyes adjusted to the burst of light from the open door, their eyes widened. Since they were drunk, they started to talk to me. "Are you a nun?" I replied that I was not. "You must be an angel." I suppose with the light behind me it was an easy mistake.

"Actually, I am a woman pastor." And so began one of the most bizarre conversations of my ordained life. Of course, the barbeque was late, and I was there for twenty minutes listening to impromptu confessions. There were tears and hugs. There was even a prayer right at the bar. Before I left the bar, I texted a parishioner who was waiting for me. "I am going to be a little late, but I have an awesome story."

I have no idea if these women would have opened up had I been a man in a clerical collar. Perhaps. But in that moment, I was glad that I was not easily classified, that my collar elicited conversation as opposed to shame. It made all the other awkward conversations, snarky comments, and sideways glances worth it.

Reflection Questions

- Do you find it difficult to engage with people about your faith?

- Have you ever had an unexpected conversation that opened your eyes in a new way?

- Do conversations about faith have to be relegated to holy spaces?

Foot Washing

It was not what I imagined Jamaica to be like. No beaches. No palm trees. Far too many teenagers. To be fair, it was Jamaica, Queens. I had no idea such a place in Queens existed until I found myself planning my first youth mission trip with my fledgling youth group. I had warned them that while we were technically in New York, this would not be the New York City they might expect. It was busy and diverse like New York. But it lacked the glamour of Manhattan. There were no fancy places to visit. We slept on the floor of a church gym with giant box fans as there was no air conditioning. It was July in Queens and I felt I was constantly sweating. I was a new priest, so new that many people mistook me for one of the high school students I was leading. I loved this group of six high school students, because they were mine. They also made me crazy.

I called them the Bad News Bears. Every morning the retreat leaders would open with a devotional. After that, everyone was encouraged to find a quiet space so they could read their Bibles and write in their notebooks. You would think it would be hard to find a quiet place in Jamaica, Queens, but the church had a sprawling campus with a fair amount of green space for teenagers to lounge under trees and read their Bibles and think pious thoughts. Most of my kids had brought a Bible, as that was on the packing list. They chose not to open the Bible. While the other teens gazed into the distance pensively, mine sat in small group looking bored. They had complained and argued for the duration of the long drive from Southern Virginia, but I hoped this mission trip would change us. From my own experience as a participant on a mission trip, I knew that mission trips usually culminate in one emotional night where even the most jaded teenagers are moved to tears.

Unlike most mission trips, we were not painting or fixing houses. We were doing community service. Most of us were

assigned to a nursing home, which we could have easily found five minutes from our church in Norfolk, Virginia. However, the point was to get the kids out of their comfort zone and experience something new. There were moments when they were able to engage with an elderly person and see the impact of their presence. They even occasionally sang the praise songs. There were also moments of solidarity when we looked at one another and rolled our eyes as we sang praise songs, because we were Episcopalians and we don't sing praise songs in the Episcopal Church. We sing hymns that none of these teenagers actually liked, but that was what they knew.

Our mission trip ended with a foot washing on the final night. In my Episcopal church, we had a foot washing on Thursday of Holy Week. We began with an agape meal, which consisted of things like hummus, pita bread, olives, and cheese. And wine. Always wine. It was my favorite meal as a vegetarian as the typical church potluck isn't a happy place for a vegetarian. After the meal we processed to church, where we read the story of Jesus washing the feet of his disciples and then washed the feet of people in the parish. It was an awkward service as we had to recruit people to let us wash their feet. Most people just came for the food and wine we had before the service. None of these kids had actually participated in a foot-washing service. Most of them only came to church when they had to acolyte.

Despite the newness of it, I had hoped that when they saw the other youth participating, they would be moved to act—just as Jesus' example moved the disciples to act. On that final night we sat on the floor of the parish hall of the church. The floor was cool, which was a welcome relief. We were in small circles, each with the youth from our church. A large metal mixing bowl with tepid water sat in the middle of our tiny circle. The lights were off, and candlelight illuminated the dusty linoleum. Soft music played. I watched as the youth in the other small circles took off their socks and shoes. I began to do the same as well as the other two adult leaders in our group. I kept my eyes on my own feet, praying the kids around me would follow suit. I was afraid to look

up. When I did, I saw that they were not moving, frozen in teenage derision. I could see them looking at one another, waiting for someone to go first. No one did.

I looked at one of the boys in our group. Eric was my one hope. It wasn't because he was any more pious than the others. He was my hope because he dared to be different. In youth group, while other teenagers binged on Doritos and Mountain Dew, he would wander off and play classical music on the piano. It was the only time I ever saw him fully alive, fully himself. He was a brilliant pianist. He was also kind and thoughtful. If anyone would do it, he would. Yet when I looked at him, he looked down, his eyes shielded by his shaggy brown hair.

I was tired. Being surrounded by teenagers at all times was an introvert hell. Sleeping on the floor with no air conditioning in a room with a hundred people had not provided a good night's sleep all week. I had worked with these kids for a year, built this small group from nothing, and there seemed to be no progress. I began to weep. Not delicate tears—uncontrollable. I could not stop. Mortified, I got up and ran to the nearest bathroom. It wasn't a great plan as there was no way to get out of the bathroom other than going back through the large kid-infested room. I looked at the window and considered trying to climb out. I would need a boost and going back into the room to ask someone to give me a boost seemed counterproductive. The other problem was that I didn't have shoes on, and I was in a public bathroom. I stood at the sink staring at my red and blotchy face, occasionally going into a stall to grab more tissue. I stayed for thirty minutes, long enough for the tears to cease, and, I hoped, long enough for everyone to leave.

As I walked out, the first two people I saw were the other adult leaders from our church. They looked worried, but not alarmed. Behind them I saw Eric. "He wouldn't leave until you came out. Everyone else is worried, but he wouldn't leave."

I looked at the adults and then at Eric. "I am so sorry. I don't know what happened. I am just exhausted and frustrated. I am

so embarrassed." I looked down at my dirty feet. Eric didn't say a word. He just hugged me as I tried not to cry again. Without a word, he left. Eric understood the ministry of presence more than most clergy I know. I asked the adults, "Did anyone wash their feet?" Perhaps my breakdown inspired them.

One of the adults shook her head. "No." While I was grateful for their compassion, I was disappointed that no one had participated. I felt like a failure. She looked at my feet. "I still have the water. Can I wash your feet?"

Usually before I've participated in a foot washing at church, I've make sure they are clean and well manicured. You never want someone to have to wash dirty feet, especially the priest's dirty feet. "I've been standing in a public bathroom. They are disgusting. You don't want to wash them."

"I want to." I wanted to crawl back into the bathroom, but fear of hypocrisy compelled me to agree. We sat down and I put both my feet in the bowl. I watched as the water turned brown. She then dried my feet and I put my shoes on. I thanked her and we all walked out together. It was evening prayer time with our individual groups. I dreaded seeing my youth group. They were sitting on two couches in a church parlor. They were shockingly quiet.

I sat down next to one of them and looked at them all. "I'm sorry to break down like that. I just feel like I have failed you."

The teenager who had always been the most obstinate was sitting beside me. He put one arm around me and gave me an awkward but sincere hug. "You haven't failed us."

This wasn't the ending I had envisioned as I visualized the perfect mission trip. But I think it was the ending we all needed. When we talk about the foot washing at church, we often talk about servanthood or humility. But now, I think of what it means to be vulnerable. I think of what it means to be human. Of all the parishioners I have worked with, these kids saw me more clearly than anyone else. And they loved me anyway.

Reflection Questions

- Have you ever experienced love after exposing vulnerability?

- What did that feel like?

- Why do you think Jesus washed his disciples' feet? What can we learn from that?

The Fig Tree

In the morning, when he returned to the city, he was
hungry. And seeing a fig tree by the side of the road, he
went to it and found nothing at all on it but leaves. Then
he said to it, "May no fruit ever come from you again!"
And the fig tree withered at once. —Matthew 21:18–19

At our first real home, we had a fig tree right outside our bed-
room window. It was on my side of the bed and on mornings
when I was not ready for the day to begin, I would look through
the cheap blinds at the fig tree. I liked to watch it move through the
seasons. I saw hope in the buds.

We moved there in the summer, one year after we married.
Previously, the closest thing I had ever had to a fig was a Fig New-
ton. I did not realize what kind of tree it was until someone said,
"You are so lucky to have a fig tree." It made me feel a little guilty
because I had not really taken advantage of the fresh figs. I had
eaten a couple figs and filled a bowl or two, but then forgot about
it until I saw the partially eaten figs the birds had spat out and left
to rot littered on the ground. It was such a waste. I vowed that the
next year I would eat more figs.

The next summer, I discovered the joy of picking fruit straight
off a tree and holding it in my t-shirt because I could not hold all
of it in my hands. After my shirt was stretched as far as it could
safely go, I went into the kitchen and dropped them in the strainer,
washed them, and ate them right over the sink. Having a tree that
created fruit made me feel like I was an adult at last. It just seemed
like an adult thing to have. If I was vigilant, I could get gobs of
them before the birds started pecking away at them. I even became
that person who would bang on the window when I saw the birds
stealing my figs. "Get off my damn fig tree." My husband would

look at me a little concerned. "Those stupid birds keep eating my figs. Then they poop on them just to piss me off."

My husband replied, "I am fairly certain the birds are not intentionally pissing you off. You just need to pick them before they get to them." My husband has no idea how mean birds can be. I went out with a kitchen stool so I could reach even the highest branches. Those birds would not beat me.

I picked so many that I had to search for recipes for figs. "You know, you can make fig preserves," my mom told me on the phone. I loved the idea of being the person who makes fig preserves— however, I did not love actually making the preserves. I made fig preserves and stacked them in my fridge. I was told you did not have to put them in the fridge if you had correctly jarred them. However, I had no faith in my jarring abilities, and they stayed in my fridge all year. I could not eat them. I could not trust that I would get the figs before the birds did the next year. I have never been someone who likes to take risks.

Because of my risk-adverse personality, it's a wonder I ever tried to get pregnant at all. I guess it was just ignorance that allowed me to believe I would get pregnant and then have a healthy baby like every other person I knew. The gynecologist presented things in such a matter-of-fact way. "We just need to jumpstart your period. You were on birth control and your system is just out of whack. We will give you some hormones and then you will get your period. Then you can start using those ovulation tests to see when you are ovulating." I believed her because I needed to believe her.

She was right that I got my period. What she was wrong about was the "jumpstart," because I went months without getting it again. "You know what, we need to give you stronger hormones that will help your ovaries to function better." I just nodded my head. I did not read about it. I knew that if I did, I would worry. "The last thing you want to do is worry about this," she told me as she handed me the prescription. "What you really need to do is relax." I hate it when people tell me to relax. When did that ever help anyone?

I did not ask about the risks until the abdominal pain started. I still wasn't pregnant despite all the hormones. I sat on the table in that skimpy cloth robe they give you as my fully clothed doctor sat across from me with a slightly concerned look on her face. "Hmmm . . . we might want to do an ultrasound and see what is going on." We did the ultrasound. It was not the way I envisioned an ultrasound. When you think of an ultrasound, you think of hearing the heart beat and getting a little black-and-white printout of a hazy blob that makes you gasp for joy.

She gazed at the hazy screen. "Oooh . . . that was what I was worried about. You have a cyst . . . a really big cyst. You must have been in a lot of pain. Weren't you in pain? It's almost six centimeters." I tried to imagine how big that was, but I never really got the metric system. After all the hormones, I had gotten used to being in pain—which is shocking because I have a pretty low pain threshold.

I asked, "How do I get rid of it?"

"Well first of all, you need to take a break from the hormones. You definitely need to stop those. Then it will just shrink. Well, it should shrink."

At this point, I wasn't willing to accept everything she said the way I had in the past. That trust I had given her had led to a cyst and no pregnancy. I asked, "What happens if it does not shrink?"

"It bursts."

Bursting didn't sound good to me. "How will I know it's burst?"

"Excruciating pain."

I wanted to swear but instead I nodded and tried not to cry.

The next morning, I woke up and immediately put my hand on my stomach, trying to determine if it shrank. I knew it could not shrink that fast. Yet I held my hands over my cyst and prayed that it would shrink. I prayed that my hands would have some special healing ability because I was a priest, and my hands were supposed to do something holy. In seminary, we were taught exactly how to hold our hands as we celebrated the Eucharist. Some students glibly referred to the hand movement as "magic

hands" because there were certain parts of the prayer when your hands had to touch the bread and the wine. Not every Episcopal priest believes this, but my professor did. My hands didn't feel like magic right now. Perhaps my hands could only be holy at the altar. As I pondered the magic my hands could command, I looked out my window and saw that the buds on the fig tree were slowly growing. It would not be long now.

Since I was off of artificial hormones for a couple of months, I decided to try some natural remedies. I started with acupuncture. An infertile friend of mine referred me to someone. My friend told me, "She's kind of weird, but I found it really relaxing." It seemed counterintuitive that having someone stick needles in me would be relaxing, but anything had to be better than a bursting cyst. The acupuncturist's office was white and beige, which was probably supposed to instill a feeling of calm. I expected her attitude to reflect the décor of her office, but it did not. She was intense and a little scary. She started by delving into all parts of my life—asking questions that ranged from my relationship with my mother to my first period. Then she looked at my tongue, checked my pulse, and stuck needles into various parts of my body. The needles were not nearly as invasive as her questions. I never went back to her.

A woman at my church introduced me to Reiki. I listened to her because I was her priest, and I could not tell her it sounded a bit crazy. I knew I would never do it. Then she gave me a gift certificate. I still could not get my period and I was off hormones . . . and it was paid for, so what the hell? Sign me up for crystals and chakras! It is hard to describe Reiki without sounding like you just walked out of a commune wearing patchouli. I would never have tried it if I had not been so desperate and not had a gift certificate.

The easiest way to describe Reiki is that it is a spiritual healing practice. It's not really Christian, although the person I went to was a Christian. The practitioner would hold her hands right over parts of my body and move the energy. She would tell me where my energy was blocked. To her, it was clear why I could not get pregnant. There was no energy down there. All of my energy was in my head and heart. I was too studious, too emotional I don't know that

she ever said those things, but that was what I heard. I was also blocked in my throat chakra. Apparently, I wasn't saying everything that was on my mind. I thought, "Welcome to the priesthood, lady." I have to spend 90 percent of my life not saying things I want to say. Some of it would be really funny.

Despite all my rational objections, I found I really loved Reiki. Being in that room, I felt cared for. It was the one time when I was in someone else's spiritual care. While I preferred the Reiki practitioner in general, I found my way back to acupuncture after getting another recommendation from my chiropractor. Both practices have some similarities. Both the Reiki and acupuncture practitioners would tell me that spring bears the promise of birth. They said that if I could just make it through the winter, I would see results in the spring. They weren't speaking figuratively. They were talking about the seasons. Despite the assurances that new life would come in the spring, I was still infertile. The person who referred me to the second acupuncturist told me that he would write the date he predicted his client would get pregnant on and then triumphantly show them his prediction when it came true.

When the figs had once again started dropping to the ground, I knew that spring was over. I gave up on natural remedies. I felt that I had failed these practitioners. I knew I could not go through another cycle of seasons in their care.

I went back on my hormones and found as I became more and more depressed, it became harder and harder to get out of bed. There was more time to stare at the tree. I watched the buds of the fig tree from my window. I watched them begin as tiny leaves and grow to their full size. I watched the tiny figs transform from small green teardrops to robust fruit. I watched and I waited for the time when my spring would happen. But it didn't. Every year I watched the fig tree bloom from my window. I watched as the fruit grew heavy with sweetness and dropped to the ground. I watched the leaves fall. I saw it all.

When we had first moved there, my husband would joke that he was going to try to curse the fig tree to see what would happen. Of all the peculiar stories in the Bible, the lesson of the

fig tree in the Gospel of Matthew is one of the ones that used to baffle me the most.

At the first church I served, there was a man who would ask me about it when it came up in Bible study. He would ask about it even when we weren't studying it. "Samantha . . . ," he would start with his deep Southern drawl, "you are my spiritual advisor and I do not understand this story and you must explain it. Why would Jesus curse a tree?" I looked it up in a different commentary every time he asked, hoping I could find an explanation that would make sense to him. While I found a lot of theories from learned scholars, there was never one that he would accept. "Samantha . . . I love you dearly, but that makes no sense." Frankly, he was right. All the theories sounded ridiculous to me.

My parishioner could not understand why Jesus would curse a tree just because it did not have the fruit he wanted. Everyone who has seen the way a fig tree progresses knows that the leaves come first and then the fruit. Why would Jesus curse a perfectly good fig tree?

Despite my inability to explain the story to one of my favorite parishioners, I began to identify with that cursed fig tree. I understood what it was to appear healthy on the outside but unable to bear fruit on the inside. The more I thought about the text, the angrier I got. It made me mad as hell at Jesus. I felt God had cursed me for no good reason. Sure, I could come up with some theories, but they all sounded like bullshit to me. I was dead inside and I always would be. Spring never came for me. My body went from the starkness of winter to the scorched earth of a Virginia summer. I could eat as many figs as I wanted, and it would not make a bit of difference.

We had a healthy fig tree that bloomed every summer. Birds fed on it. I fed on it. It was I who was cursed, and I will never forgive that damn tree for showing me up. Thankfully we moved. I miss the figs, but I don't miss that tree that insisted on showing off right in front of my bedroom window.

Years later, after we entered the adoption process, one of my best friends (who also adopted) said, "It doesn't go away, you know."

"What?"

"The grief and the pain of not being able to carry a child. I love my boys and am so happy that I have them. But I just don't want you to think that once you adopt, you won't feel the pain anymore. It's not as bad, but it's still there."

It's the best advice I have ever gotten about the transition from infertility to adoption. I still get irritated when I see someone get pregnant right according to plan. I love my son and often remark to people that he's more special than the child my husband and I might have created, because he's unique. I marvel at our differences. But there is a piece of me that will always feel cursed. I have forgiven God and the fig tree. Now I identify more with Jesus in the story. His decision to curse that tree was probably related to some pain he was experiencing. It wasn't rational. Pain and bitterness rarely are. I can't judge myself for my anger. It doesn't diminish my love for my son. When we moved, my husband planted a new fig tree. It's been six years and it's never borne any fruit. It's just there, trying to survive. I'm OK with that and I think Jesus is too.

Reflection Questions

- Is there a Bible passage that is particularly meaningful to you because it speaks to something you have experienced?

- Has the impact of the passage changed as you have aged?

- Have you ever been angry at God? Do you feel guilty about that anger? What would it take for you to forgive yourself of that anger?

#Blessed

Blessed are you who are poor, for yours is the kingdom
of God. Blessed are you who are hungry now, for you
will be filled. Blessed are you who weep now, for you will
laugh. —Luke 6:20–21

M any clergy claim the Beatitudes as a favorite passage, partially
because it's comforting and people want to be comforted. I
don't find it comforting at all. I love to preach it because the idea of
being blessed has been usurped by secular society, leading to many
assumptions about this text. What I love about this text is that it
rejects the humble bragging we see on social media. Someone will
talk about a recent achievement or share a picture of their beau-
tiful child. Then they will write something like, "So blessed!" I
always want to write in the comment section, "Congratulations,
but perhaps that's not what it means to be blessed." But I don't,
because no good ever comes from preachy comments. Jesus never
associated blessing with positive things such as wealth or a good
job, or even a beautiful family. He said, "Blessed are you who are
poor . . . blessed are you who are hungry . . . Blessed are you who
weep" Poverty, hunger, and sadness are not experiences most
people want to be blessed with.

When I hear this text, I am reminded of the summer of 1999. It
was the summer when Brittany Spears was fresh and new, before the
shaved head and divorces. It was the sweet time right before most
people had cell phones. There were car phones that rarely worked. It
was the summer of my first love and my first true heartbreak. It was
the summer after I graduated college. It was also the summer I lived
alone for the very first time. My mom told me, "This will be good
for you. If you can live by yourself and still like yourself by the end,
you will know you are all right." I had a serious depressive episode

only six months before and almost left school my senior year. No one was sure if I was really all right.

I was working in a small town called New Bloomfield. I had gotten an internship doing youth ministry in a church in a town with no stoplight and a pharmacy that was not connected to a drugstore or a Walmart. It was just a pharmacy, which I found absolutely charming until I realized that I was picking up my antidepressants from someone who might attend the church where I was ministering. I did not know anyone in the town and my closest friend was hours away—that was not so charming. But I had an amazing boyfriend, whom I knew would visit me often. That meant I would not really be alone. When I arrived in that small town two weeks after graduation, I felt that for the first time my life I was in a good place. Two weeks later, my amazingly perfect boyfriend returned from his mission trip to Ecuador and dumped me. The delightful and quirky country town turned into the movie set of *Seven*. Everything was gray.

I cried all the time and took long walks in the predawn hours since I could not sleep. I started attending weekly Mass in a Catholic church I was not working in (because I could cry there and no one would ask me why). I went to a small Bible study on Tuesday morning. I was the only person under the age of seventy. I do not recall what we were studying, but at one point the priest said, "Being blessed is not the same thing as being happy." I wrote it down in the Bible I had to buy for my entry-level New Testament class my first year of college. It was all marked up with smart college commentary. I was proud of that Bible.

In the predawn hours, I drove to a national park nearby and cried. There was a pasture of cows that I passed every time. One day I found myself mesmerized by those cows. I've always kind of loved cows. It is the primary reason I became a vegetarian at the age of sixteen. I looked at those cows as they lay in the sun and chewed on the grass. "I wish I was a cow. That looks like a really great life." This thought halted my tears long enough for a surprised laugh. I was genuinely jealous of a cow that was probably going to be slaughtered.

I was reminded of that moment thirteen years later. It was morning, although not quite as early. The sun was flickering through the trees as I drove to a meeting, once again crying. I was annoyed that the day was far too beautiful for the mood that I was in. I cried all the way to my meeting—well, maybe not the whole way. It was a ninety-minute drive and even I had a limit to how much I could weep at one time. I complained to my husband about the meeting the day before.

"I just don't think I can handle that meeting if I have a negative test."

"Why don't you skip it? You have always said the meetings aren't the best use of your time and that one is in the middle of nowhere."

"I know, but the meetings are mandatory, and the bishop is there. Besides, we only meet six times a year."

"You are way too responsible for your own good. The bishop will understand. You can decide tomorrow morning, depending on the result. Besides, I have a good feeling about this one."

There was no plus sign the next morning on the pregnancy test. I was still buying the branded pregnancy tests, still thinking generic wasn't good enough. That changed after about thirty negative tests, but I wasn't there yet. I had just completed the two-week wait. When you are trying to get pregnant almost everything is measured in two-week increments, and every two-week wait seemed interminable. I knew that the two-week-wait mark fell on the same day as my executive board meeting. The executive board listens to reports about the diocese from the bishop and the members of the bishop's staff. We vote on things sometimes and then we eat lunch.

My husband was right. I am far too responsible. If I agree to do something, I show up, even if it feels like my world is falling down around me. So, despite the negative result and my devastation, I left my home early because that is what obnoxiously responsible people do when they have a long drive. As I pulled into the parking lot of the small country church, twenty minutes before the meeting, I felt pretty good about the fact that I had

managed to stop crying. With the extra twenty minutes, maybe the splotchiness would recede a bit and it would not be so obvious I had spent the last hour crying. After examining myself in the mirror, trying to determine if my waterproof mascara passed the test, I looked across the street and saw a pasture of cows, lazily grazing on the green grass. "I wish I was a cow."

The gush of tears that I had worked so hard to stop threatened to reappear—but these were different tears. They were angry and bitter and not at all appropriate for someone about to walk into a gathering of clergy. The bitter feelings came not only from the memory of that woeful summer and the disappointment of that morning, but the realization that nothing had really changed. Sure, I was married with a job and a dog, but my emotional state remained the same. I was feeling lost and depressed, looking at cows grazing in the sun and envying them. I had been through so much, and yet here I was again jealous of cows. I was thirty-five years old and a priest serving on the executive board of my diocese, and the only thing I really wanted was to lie in the grass and forget it all.

I dropped my forehead to the steering wheel and practiced my deep breathing. So not helpful. Whoever decided breathing is helpful for relaxation was full of crap. Since I was still early, I decided to find a spot with a better view of the cows so I could truly wallow. I was not convinced that I would not break into tears while the diocesan treasurer read the financial report, which, while depressing, was not worthy of my tears. I clutched my cell phone like a rosary and debated calling someone. But what could they say? There was nothing to say about another failed attempt at pregnancy.

I saw my bishop in his purple shirt climb out of his silver SUV with his retro briefcase, which I was fairly convinced held nothing. He started to walk by and then hesitated. He knew something was wrong because, while I am a proud introvert, I rarely miss an opportunity to get the good seat at the table and scope out the best breakfast snacks.

"Well, this can't be a good sign," he said as he sauntered up.

"Hi bishop. I'm fine. It's just so stupid. It's just . . . I had another fertility treatment and I just took the test this morning. Negative." He looked down at me as he swung his briefcase back and forth. He looked up for a moment, then down again.

"I am sorry. I know this has been a frustrating journey for you. My wife and I have been praying for you."

"Thank you. That means a lot." I meant that too. No matter how much I doubted the effectiveness of prayer, I never doubted how much it meant to know someone was praying for me.

"You can stay out here as long as you want."

"Thanks. I will be in there in a few minutes." Although his words were not inspirational and would never have made it in the consolation message of a Hallmark card, his presence brought me comfort. If I didn't make it in, he would know that I was out here, and his mere knowledge of that made me feel like I could get up and go into that meeting. I could make it through the entire financial report without shedding a tear. I realized then why having a pastor mattered, even when that pastor didn't have the right words. Just being present helped. Perhaps that was what God's presence meant. God knew I was suffering. God knew I was angry at him and the world because I could not do something so very basic. Yet unlike so many, God was not made uncomfortable by my anger. He didn't try to cheer me up. He didn't remind me of how truly blessed I was. He was just there with me watching the cows.

I heard the word "blessed" a lot after we adopted our son. People told us how blessed he was, and my husband and I said, "No, we are blessed." While I was still tempted to correct people on their interpretation of the word, "blessed" seemed kind of appropriate for adoption, or perhaps just parenting in general. There are tears and sorrow. There are also moments of intense joy. One moment my son is bringing me flowers that he picked and the next he is trying to bite me in the knee because I won't let him stay in his overly saturated diaper. Those moments might be within minutes of one another. When I step on a Lego, sometimes I still smile because I remember how much I longed for toys scattered on the floor. But sometimes I step on a Lego and break out every curse

word I can think of. It all depends on how grateful I am feeling that day or hour. It also depends on the shape of the Lego.

Recently I preached on the Beatitudes and told the cow story and my summer of woe. I shared some of what I thought it means to be blessed and what it doesn't mean. I never preach things I do not believe, but I often preach things I need to hear. Because the truth is, I am still not sure what it means to be blessed.

Afterwards, a parishioner who I knew had suffered a great deal over her life asked, "So what does it mean to be blessed?"

I responded, "Well I guess being blessed just means being in God's presence and actually being aware of that presence."

She nodded and smiled and said, "That's what I think too."

Reflection Questions

- What does it mean to you to be blessed? Do you feel blessed? What does that look like?

- How does it feel to know that you are being prayed for?

- What might it mean to others to know that you are praying for them?

Meeting the Birth Mother

I knew that the mother of this child was somewhere in the hospital. Every time I had walked down the hall from the entrance to the nursery, I had found myself looking at the floor, afraid I would see someone wandering down the hall, someone who was about to do a painfully hard thing. I knew why I should meet her. It would be better in the long run if I was able to tell my son something about his birth mother. I also hoped that it would be some assurance to her. When we were told that she did not want to meet us, I was relieved. I was scared of what might happen if she chose to meet us—scared she would change her mind, scared she would take one look at us and doubt her decision, scared that she would weep and leave me feeling even worse than I already felt. Scared.

One hour before we planned to leave, our adoption agency contact breezed into the room. She was young, blond, and dressed perfectly appropriately for a spring day in Florida. "Hello! I am Lily. It is so good to meet you finally." (We had only been talking for the past day, but it had been a long day.) "So, the birth mother has changed her mind." Panic set in, but not a complete panic because her tone was still chipper and positive. "She does want to meet you. She is still committed to her adoption plan but feels it would be reassuring to meet you. She is right down the hall."

I looked down at this baby who was not yet ours. He was awake for once. "Now . . . she wants to meet us right now?"

"Of course. Don't worry about it. It will be fine."

I adjusted the baby's pacifier. It was too big for him and I was afraid he might have trouble breathing. "Do we bring him? Has she seen him or held him since she gave birth?"

"No."

I looked at my husband and he looked as panicked as I felt. He nodded and we both stood. I whispered, "Oh my God. What are we supposed to say? This is crazy."

Just as we entered the hall, Lily looked at me in what I assume was her understanding expression and said, "I know. This is a loss for everyone."

She walked ten yards and stopped in front of a closed door. The birth mother's room was adjacent to the nursery. This whole time she had been right there. I thought I would have more time to prepare, a few more yards at least. Conor looked pale and bewildered.

"Do I say 'thank you'?" he asked. "That's just not enough."

For once, I had no advice. I looked down at this perfect baby. "Nothing would be enough. There are no words that would possibly be enough." Conor nodded.

When we walked in, she was sitting up in her bed eating her lunch. She immediately got up. I was distracted by her distended belly. She looked like she was about to give birth. I had seen women right after they had children when I had visited new mothers and babies in the hospital. I knew that mothers still had the belly right after birth, but not quite this big. She was small. Maybe that was why it looked so big. Or maybe it was because the jersey dress she was wearing was skintight. It was an NFL team, and the dress just barely covered her. I was embarrassed for her. After all that she had been through, now we were invading her personal space. She did not seem embarrassed. She smiled. Her smile was not like my politely hesitant smile. It was wide and beautiful. Her smile made me forget for a moment why we were there. It was the kind of smile you had to reflect.

"Oh, you have such sweet spirits. I know this sounds a little crazy, but I have this thing. I can feel it when people have sweet spirits. I see it in you. I feel so much better just to see you."

Conor and I looked at one another. Did she know we were clergy? Of course, it didn't sound crazy. We talked about spirit all the time.

"Thank you." I felt my shoulders relax.

"Thank you so much," Conor added.

"I know that is not enough. I know there is no way we can ever thank you enough."

"This is the right thing. It was just bad timing" Her voice trailed off and her smile faded for a moment.

"All I can promise is that he will be so loved. Our families are so excited. And our churches. You know, we are both pastors and we each serve different churches, and they are both so excited."

"Oh . . . I did not know you were pastors. I knew you met in seminary."

Lily chimed in, "That must make you feel good. Church is so important to you."

"It is. My church is my family. They are so important to me and my daughters. Would you like to see pictures of my daughters? That makes me feel so good that you are pastors." She got out her phone and showed us a picture of two girls dressed up in their Easter finest.

"They are lovely. Maybe we can meet them sometime. If you ever want to see him, we can come down. We have other family here. It's up to you of course." I hurried through the last few words when I realized what I was offering. This was not part of the plan. We had not agreed to visitation. Our adoption was partially open, which meant that we would send updates twice a year but we had no obligation to do anything other than that. That was the way we wanted it. That was what the birth mother wanted as well. The idea of visits to the birth mother had been terrifying to us, but standing there, I would have given her whatever she asked. I wanted what was best for her. I looked at Conor, hoping he was not mad at me for this offer.

"We want him to be able to meet his half-sisters if he wants to and you want to. We don't need to decide now. But we do have family here. That is where we are staying." Apparently, he was feeling the same way I was.

"Would you like to see a picture of our family? Conor, can you get your phone out?" He swiped through the pictures.

When the photo of our adopted Chinese nieces and nephew came up, she said, "Oh, that's good. You already have some diversity in your family."

"We do, and it makes our family special."

Lily stepped in. "Would you all like a picture together?" We all looked at one another, none of us sure how to react. "It will mean a lot to him someday, to have a picture of you." Conor and I turned to the birth mother. It was her decision.

She nodded. "OK." Conor and I stood on either side of her as I held the baby. We smiled, pretending this was not the most awkward photograph ever taken.

While the picture was being taken, I steeled myself for what I knew I had to do. I knew this was the first and possibly the last time she would hold him.

"Would you like to hold him?"

She paused. "Yes, I think I would." She looked down at him, kissed him on the forehead, and said, "Goodbye, little man." Tears welled up in her eyes and it took all I had not to burst into tears as well.

All I could say was, "I am so sorry."

"Oh no, these are tears of joy. This is a holy day."

"Well, it is a Sunday. Sundays are meant to be holy days. I promise we will love him so much." She nodded and handed him back to me.

Lily piped in, "Alright, well let's let Keira get back to her lunch. I will see you soon and we can get you discharged."

I was so happy that she gave him back to me and that she felt good about us, but I knew those were not tears of joy. I thought of her returning home with a pregnant belly but no baby. I wanted to lie on the floor and cry. I knew that I could not break—not now, not ever. I had to hold these dueling emotions in my heart forever; the joy that comes with a child and the guilt of knowing that I had this child because someone else could not.

I was reminded of a Scripture reading called "The Song of Simeon." According to Jewish custom, parents of newborns were required to bring the newborn to the temple and present him or her to the Lord. When Mary and Joseph brought Jesus, they encountered a man named Simeon. He was a pious man and believed that he would not die until he saw the Messiah. Because he was filled with the Spirit, he was able to see this infant for who

he truly was, the Savior of humankind. Upon seeing Jesus, he took him in his arms and said, "Master, now you are dismissing your servant in peace, according to your word, for my eyes have seen your salvation, which you have prepared in the presence of all peoples, a light for revelation to the Gentiles and for glory to your people Israel" (Luke 2:29–32). While Mary knew that this baby was divine, she was probably a little murky on the details. This would have been affirming for her considering all she had been through. It might have even been a moment of pride given the wonderful things that Simeon shared. However, Simeon was not done yet. He added: "This child is destined for the falling and the rising of many in Israel and to be a sign that will be opposed so that the inner thoughts of many will be revealed—and a sword will pierce your own soul, too" (Luke 2:34–35).

That last line has always intrigued me. This prophesy about Jesus had been hopeful. Yet the tone shifted dramatically. The last thing Simeon told the mother of Jesus was that a sword would pierce her soul. I wonder if she knew what he meant or if she simply dismissed the words as ramblings of an eccentric old man. Given all the turmoil Mary had already experienced, she must have known this was not going to be an easy journey. That said, not even Mary in her wisdom and piety could have possibly known how right Simeon was. She would not have really known until she sat at the foot of the cross and watched her son tortured to death. What agony that must have been. After Jesus died, they stuck a sword in his side to make sure that he was dead. It must have felt as though they were piercing her soul.

As I walked out of that room clutching my little bundle, I felt Simeon's words. I felt them personally and, to some extent, I felt them on behalf of his birth mother. She had carried this boy in her for nine months.

I knew what the social worker meant when she said it was a loss for everyone. She meant that it was a loss for the couple who couldn't have a child who shares their genetic traits. It was a loss for the birth mother, who made a tremendous sacrifice for this baby. It was a loss for this baby, who would struggle later in life

with his identity and feelings of abandonment. I couldn't speak to the experience of the birth mother or the adopted child. For me the loss was not about what could have been; it was about knowing that this child would never be completely mine.

One day, he would ask me about his "real mother." He would ask me why she gave him up, why she kept her daughters and not him. I will not be able to answer those questions. I won't even be defensive because those are important questions, and they speak to his experience. But I know that I will feel that sword every time those questions come up. I will feel the sword every time people look at my family with a confused look and politely look away. I will feel the sword the first time he comes home from school sad because someone made fun of him for his different family. I will feel the sword when he says that I just can't understand because I am White—because he will be absolutely right. I will never understand him completely, but I will do what I told his birthmother I would do. I will love him with all my mind, body, and soul. Even though my soul will be pierced by a thousand swords, I will love him and remind him that he has not one mother, but two.

Reflection Questions

- Have you ever benefited from the sacrifice of another? What did that feel like?

- Is love always complicated in some way? Does it always involve some degree of pain?

- How can God help us with that kind of love?

Relinquishing One Privilege

A dopting an African American baby was a difficult decision for us. We never doubted that we could love an African American child. We were confident the race of our child would not affect our love. We were worried about the experience of the child. We had read the literature about transracial adoption; it is controversial, especially in the Black community. There is doubt as to whether a White couple can raise a happy, well-adjusted, culturally aware Black child. I had seen a White couple in my church adopt a Black child. But that was different, as he was eleven when he was adopted and was able to stay in touch with his family of origin. It was still incredibly hard, but that child had the Black experience to an extent, whereas our child would only ever know a White family. When making our decision, I spoke to that child, who was by then a man. I had led his youth group for seven years, and while I loved all the youth I worked with, he was special. He was everything I would want my son to be.

"Marquis, we are thinking of adopting an African American baby. Just be honest with me. What do you think?" I had known Marquis for ten years at that point. I was fairly certain he would be honest with me. He didn't hesitate.

"I think that you would be a great mom."

"Thank you, but I know that there are people who think it's wrong. You had great adoptive parents, but I am sure it wasn't always easy for you."

"Of course, there are people who think it's wrong. There will be people who judge you. You will get a lot of looks. I remember being on a plane once and a woman came up to me and just touched my skin. It was like she had never seen a Black person. It was weird. But you know what, it's going to be worth it. And I will help you. If you have questions, you can always call me."

There was more research and more conversations, but that was the one I always returned to. And Marquis was the one I called when Joshua's hair grew long enough so that he cried when we tried to pick it out. For many years it had been me who had provided advice and guidance. Now, it was his turn.

When we were debating whether we could adopt an African American baby, I spoke with one of my closest White friends and said, "You know, I just don't want to feel guilty all the time, like I am not a good enough mother."

"Well that's just life as a mom. You always feel guilty about something. This is just one more thing to pile on."

I laughed and said, "Well, I am sure you are right, but this is a big thing."

"I know that. I am just trying to say, don't let that be the deciding factor."

In the end, we left it in God's hands, and the hands of the mother who would choose us. What a lot of people don't know about domestic adoption is that the birth mother gets to choose who adopts her child. We provided a portfolio that was full of information and pictures and prayed that someone, no matter what race, would choose us. We were chosen by an African American woman, to whom I will be indebted for the rest of my life.

Like most new mothers, I was anxious about leaving home for the first time with a new baby. What if I dropped him getting him out of the car? What if there was a car accident? What if he started screaming in the middle of the store? Those were concerns, but not the main concern. My greatest fear was the looks I would get, the comments that might come. I was not ready to be judged, especially not in my sleep-deprived state. My first big outing was a trip to Target. While I was getting ready, I thought of reasons to delay the trip. I could return the things later. I could order stuff online. I could wait and go without the baby. I was embarrassed to admit to anyone why I was actually afraid of going. The trip was typical of any trip to Target in that I left with far more than I intended. It was unremarkable. The African American cashier looked bored and not at all worried about me and my family.

That fear hasn't gone away. We live in an area that is 50 percent African American. When we go to the beach, the majority of people are African Americans. The White people go to a different beach for the most part. The park is predominantly African American children. It's been six years and it's gotten easier—but I am always aware, always prepared to defend myself.

When Joshua was three, I attended an anti-racism training. I had attended a few before, but this was my first time as the mother of an African American. It changed everything. When we talked about White privilege, one of the trainers asked the White people in the room what privilege we could relinquish. We were not supposed to say it out loud, which was a relief because I could not come up with anything. Part of White privilege is that you are born with it and as long as you are White you experience it. But the question remained with me. I am not sure it would have if I didn't have an African American son.

I realized that one of the many privileges that I have taken for granted is the ability to fit in and be comfortable in most places. There have been times in my life when I have been in the minority, but it's always been temporary. After college, I worked in a neighborhood that was primarily Puerto Rican. I felt my otherness every time I left the building. So I didn't leave it very much. It was partially for fear of my safety, but it was mostly the looks that I got, the constant awareness of my White skin. White people aren't used to thinking about their White skin. If we are feeling different, it's usually our choice. I chose to work there, but I also chose to remain separate. I didn't realize I was doing it at the time. I chalked it up to safety.

I decided that the privilege I needed to release was the expectation of being comfortable. In a sense that was kind of lazy on my part—I had no choice in that my family would always look different, no matter what group we were with. There was no place we fit in. But before I had resented that feeling of discomfort. I had wanted to move past it. I decided to embrace it. In the pandemic, I met weekly on Zoom with a diverse group of pastors. We talked about race a lot. When I found out our church had owned slaves,

I told them because I knew it shouldn't be held in secret. When our church began a conversation about a Confederate memorial in our cemetery, I asked some of the African American pastors to talk to members of my church about their perspective. It was uncomfortable and awkward, but also an incredible learning experience. This diverse group of pastors supported me through it all. They often said, "We've got your back."

One day one of the African American female pastors called me up. "Samantha, I'm hosting a conversation with pastors who are also mothers of Black sons." I panicked. My son was four and I was White. What did I know about this topic? I worried that if I engaged in the conversation, it would appear that I believed I deserved to be part of the conversation. I didn't want to seem entitled. But I also couldn't say no.

"Are you sure you want me? I mean . . . I just don't know that I can speak to this."

"You are a pastor, right?"

"Well, yes."

"And you are the mother of a Black boy, right?"

"Yes, but . . ."

"You will be fine. This will be casual."

I put down the phone and debated whether I could get out of this. Then I remembered that privilege I was supposed to relinquish. I texted her and explained that I would do this, but perhaps I could provide a little disclaimer at the beginning. I decided to own my ignorance and privilege, admit that I didn't know what I was talking about.

The conversation went well and while I felt inadequate the entire time, I realized that we had some important things in common. We were all scared for our sons, and we had good reasons to be scared. We all loved our sons and were convinced that they were the brightest and best. I still worried about how people would judge me, but I also felt affirmed by a community I admired.

A few months later I was with Joshua at the park, and he was playing with an African American boy who was about his age. I stood with the boy's father and made casual conversation. The

father had run a preschool and assured me Joshua's behavior was age appropriate. This was a relief to me. At one point his son called out to Joshua, "Let's play cops and robbers."

Joshua's eyes lit up. "How do you play that?" He had never played it, but it sounded amazing to him.

The boy started explaining and his father interrupted. "Nope, you are not playing that game right now because neither of you is going to be the robber."

I smiled at him with gratitude because I had been thinking the same thing. In that moment I felt understood, even though I was the other.

Reflection Questions

- Have you ever felt like the other? What did that feel like?

- What privileges do you have? Are they ones that you earned or ones you were born with? Are there any you would be willing to sacrifice?

- As Christians, do you think we should be comfortable most of the time? How can we live into the discomfort?

Chapter 4
Melissa Q. Wilcox

Everything Happens for a Reason—NOT!

I always thought there would be tomes written about childbirth and theology. Yet when I was pregnant with my second child, I took a look around and found that pregnancy and predestination was not a popular topic in the Library of Congress. I guess the early church fathers did not give much thought to the life experiences of the early church mothers! I had been ruminating a lot about the theological implications of childbirth. Having had an emergency C-section with my first child, I wondered if God would see to it that I could deliver my second baby the old-fashioned way

I have never forgotten a chance encounter with a woman from my birth class on the local playground, after my first child was born. We had been in the same small group and I knew from her raised hand during our breathing instructions that she was absolutely a devout follower of natural childbirth. I was too . . . until my first son was born after two days of labor, a sudden drop in heart rate, and then a surgeon's knife—instead of a meditative mantra. Yet we were so thankful he was brought safely into the world. As she and I were pushing our babies on the swings, she reminisced about her blissfully natural experience with her midwife/doula team. She finished recounting her childbirth story and then asked me about my birth. I was caught not knowing if I would be judged for my delivery. I shared some sparse details and she looked at me with sincerity and remarked, "You must have been so disappointed." I found myself wondering what I should say to that

comment. We pushed the swings in silence for a moment and then she recovered by saying, "Well, you know, everything happens for a reason." I cannot tell you how many times, particularly as a clergyperson, I have heard this cliché. Sometimes I argue; sometimes I nod and smile. I chose the latter that time.

Scripture, specifically the Gospel of Matthew, tells us that God counts every hair on our head, implying that God is at work in the finest details of our lives. I began to wonder if God would guide every contraction when I went into labor for the second time. Would God see to it that those contractions would create the literal space to push the baby out via a VBAC (vaginal birth after cesarean)? This was certainly my hope and we had hired a doula during this pregnancy to help us with breathing, bouncing on birth balls, and holding my sweaty hands.

Elizabeth Christie was born on an early Tuesday morning. We had been watching and waiting and waiting and watching. Monday morning, I woke up with contractions and saw the doctor. All was well, but I was not in any way in "active" labor. I love all the medical jargon. What kind of labor is inactive? Anyway, my doctor scheduled an induction for Friday if the contractions didn't get precocious. I had the rest of the day to rest on the couch and try to get those slothful contractions into active ones. Well, the contractions eventually heard my plea and did their job.

Please note: do not read on if the words "labor," "delivery," or "childbirth" make you queasy. Otherwise, I have a pretty good story to tell. By about 9 p.m., after a nutritious McDonald's vanilla milkshake, the contractions started getting very close together. This never happened with our first child without the help of our friendly drug Pitocin, so I didn't quite believe it. Finally, I realized it was time to call our neighbor and our doula. Our neighbor made it to our house in time to tell us to stop worrying about changing the sheets on the master bed. "I'll sleep on the couch," she exclaimed as she tried to usher us out the door.

I got in the car and paged our doula. We were on our way in the dark of night and it felt just like a movie. Breathe, quiet, breathe, quiet. We reached the hospital and found the after-hours

entrance, but it was boarded up and under construction. My husband shepherded us through a dark alley of sawdust and hanging wires and we walked around the perimeter of the hospital to the ER. I could tell he was a bit more stressed than I was because he violated the space of the people right in front of us and said, "We need to get into the hospital." The woman at the desk kindly asked him to wait. We waited and then they brought me a wheelchair to be rolled up to labor and triage. I can attest that it's very hard to make small talk with the hospital candy striper when you have already labored through a tunnel.

All I remember of triage is the lack of privacy. They placed all the women in labor in makeshift rooms with only curtains as walls. We all know how much effort hospitals put into HIPAA—and not leaving messages on your answering machine. Well, how ironic was it that the whole triage center knew they hadn't tracked down my medical file yet? Soon everyone knew that I was six centimeters dilated and I'm sure they heard my whole ob-gyn history. My husband, Adam, was distracted by the blaring of the show *Family Guy* on the TV next to us. (Not the best way to get your husband to be fully available to you as you breathe your way through another contraction.) We both recall hearing the patient next to us wondering aloud why anyone would take Britney Spears' kids away. After all, aren't those children raised by nannies anyway? Finally, we got moved to our own private birthing room. In my distraction, I almost left my underwear behind in triage as a parting gift.

When we got to our room, we realized that I must have paged somebody—but not our doula. So, we waited for her to arrive and began to work with the birthing ball and the couch and the chairs for those contractions. I was very glad to see her when she finally appeared in my room. She was such a calming and warm presence. I eventually got to eight centimeters and was helped into the tub. We have a photograph of me lying in that tub covered by a towel, as Adam holds my hand, perched on the side of the tub. At first, I was comforted with warm water and the monks from the Society of St. John the Evangelist singing a simple Anglican chant. The predictability and rhythmic singing really helped me

for a while; then I told Adam, "Turn those monks off—they have no idea." It was transition time and everything was excruciatingly hard, but especially while listening to placid and celibate monks. I pushed for three hours, including using some kind of acrobatic bar, and we were still without a baby. So, instead, Elizabeth was born by C-section at 5:53 a.m.

As a priest, and somebody who is prone to think theologically, I have often applied various theologies to the whole experience of childbirth. I had wondered if, and to what extent, God would intervene in something as specific (and, in some ways, minuscule) as my own labor. I know God is not some distant watchmaker who puts things in motion and then walks away—that is deism. However, is God as obsessed with every contraction as God is with each hair on my head? Was I predestined to have a C-section at the end of both of my labors? (Just a wee bit of Calvinism here.) Why didn't God intervene in my labor, or did God intervene? Were those C-sections God's intervention after all? Even a generation ago, either I or the babies could have died without the anesthesiologist's needle in my back. I had so many questions about a literally life-changing event.

You see, I used to have this romantic image that labor would be a very spiritual experience where I would focus on this icon I have of Mary and Elizabeth as expectant mothers. I thought that I would be one with the Holy Spirit as I tried to bring forth new life. Instead, the closest I got to that was listening to the monks chant in their beautiful and resonant chapel. And then that went to hell in a handbasket when I could barely breathe in the tub.

I've been thinking a lot about Mother Teresa and her book *Come Be My Light*. In that book, Mother Teresa reveals that she had an ongoing sense of spiritual emptiness. She expresses, through letters to her spiritual director, a feeling of void when it comes to actually feeling the presence of God. This has troubled Christians and secularists alike. Isn't Mother Teresa supposed to be an icon of holiness? For those of us who know that Christianity is not contingent on our feelings, Mother Teresa's void may not be a shock. My night and day of labor did not always feel

like God was right there with me, especially as I "failed" to avoid another C-section. I wanted so badly to have a vaginal birth, but the moment Elizabeth was revealed over that curtain, I knew another miracle had prevailed.

Through my husband, doula, the nurses, doctors, and a mantra a friend gave me that "saints and angels were with me," I did know the presence of God, and the flesh and blood of Elizabeth Christie, as she was pulled out of my distended belly. This wrinkled, red, crying being reminded me that even God came into this world in a messy way, just as my own daughter. God came into this world to save us from the mess we were making. And God does care about every hair on my head, and maybe even every contraction. However, just as labor and delivery is unpredictable, so too is the mystery of our God.

I may have been a little disappointed by the way in which Elizabeth came into the world. Yet there is no doubt in my mind that her presence, her life, her flesh and blood, and her spirit have been a revelation of God and have informed my life as both a mother and a priest. Maybe someday, if she becomes a mom, she will stumble upon some solid theological reflection on childbirth. In the meantime, I will tell her that God does count every contraction, every time.

Reflection Questions

- Have you ever struggled with your relationship to God around issues of fertility, pregnancy, or labor?

- Did you find any solid theological guidance as you were navigating these challenges?

- Do you think that women theologians can make a difference for the Christian life? If so, how?

Roadblock to Bliss

I don't remember a time in my childhood that wasn't interwoven with a church. I was the youngest child of an Episcopal priest, having been born two years before my father died of testicular cancer. I don't remember that man at all. From time to time, I attempt to conjure memories of him, like the way he liked to place a wet washcloth on my head. But those memories come from pictures in a worn photo album that I paged through over and over, grasping at ways to embed a memory in my mind.

My poor mom. She was a young widow raising two kids. I used to ask her relentlessly, "When is Daddy coming back?" She would reply, "Daddy died. He's not coming back." And like a typical two-and-a-half-year-old, I would repeat her statement and with exasperation in my voice, "I know he died, but when is he coming back?" I'm told by our family friends, who functioned as babysitters as well, that I got smart about this whole "Daddy dying thing." When it was time for me to go to bed, I would say, "I miss my Daddy," and our teenage babysitters, who were still grieving the loss of their young priest, would pull me out of my bed, read another story, and let me stay up much later than I was supposed to.

But the truth is, and was, that I did miss him. I have vivid memories of a sewer pipe in our front yard where I used to go to talk to him. I guess I thought that by talking into the void he might hear me. Maybe it was just a safe place to go and chatter—who knew I could get free therapy at age five? Eventually, I did grow out of manipulating my babysitters, but I always wondered what a clean-shaven face and a bit of Old Spice might smell like.

I later loved a few men. My first love was Pop. He was handsome, almost Kennedyesque in looks. Thin and trim, and oh so gentle. Pop was my mom's father. He was an Episcopal priest too, and later became a bishop in the Diocese of Connecticut. Some

people jokingly referred to him as "the sexy bishop," but I just knew him as Pop.

I would climb onto his lap as a young girl. On Christmas Eve, just before he had to celebrate the Midnight Mass, he would read to all the cousins gathered around the important gospel of *The Night before Christmas*. We would then burrow into bed under those deep down comforters in that gigantic rectory in Greenwich, which not only was three stories, but had nine bathrooms total. I remember his study, where he would retreat every morning to pray. I remember his pjs and tartan plaid bathrobe, and I remember waiting for him to be ready to lift me onto his lap, so I could rub my fingers across his stubble, when he had finished his prayers.

Pop was a good listener. Pop loved me and would tickle my back on long car trips. We would sing "Come Ye Thankful People, Come" if we traveled together on Thanksgiving. He had a beautiful voice. When Pop was dying of ALS, we had our last visit and chance to say goodbye. Even though his limbs had failed him, he still had that voice to communicate his love with us. And while I don't know if he thought I had a vocation for ministry, I know he would be ever so proud of me as a fourth-generation Episcopal priest. On my ordination, my grandmother, his wife, gave me his pectoral cross and wrote that "Pop would be bursting with pride."

Perhaps Pop knew that I served my dolls mini marshmallows as Communion wafers when I was a little girl. Maybe he knew that I would grab our Book of Common Prayer and greet my dolls with the Sursum Corda, "The Lord be with you." "And also with you," they would reply. Etched into my DNA were those familiar words and the sharing of that sacred meal with my dolls and teddy bears. Maybe Pop saw I did have a call way back when

In my teenage years, my next love was Bronnie. Bronnie was an international businessman working in mysterious places like Nigeria and Ghana. Bronnie had three boys, but he adopted me as a stand-in daughter. He even traveled to my high school to attend the father-daughter dance. My heart was broken when the sudden phone call came, my junior year in high school, that he had suffered a heart attack and died while scuba diving. These

men—they just break your heart and leave you, like a clichéd country music song.

So, it was a long time until I loved again. And then I met Adam. Yes, another Episcopal priest. (Well, not when I met him, but on his way at the tender age of twenty-five). I know, Freud would have a heyday with this love story. I assumed, when I went off to seminary, that I would be single. I could not imagine anyone falling in love with a woman whose job involves revising sermons on Saturday nights, making frequent visits to sterile hospital rooms, and a sincere and earnest desire to discuss "the will of God" as it pertains to all kinds of things. I even remember coming up with a great comeback when people asked if I was dating; I would say, "Nobody walks into a bar and sidles up to you and asks, 'What's your favorite Gospel?'"

So, ironically, I was sitting in the seminary dining hall and was discussing whether God is both omnipotent and omniscient with another seminarian. Adam was sitting at the other end of the table. He tried to jump into the conversation with somewhat of an inane comment. I later learned he did so because he thought I was smart, compassionate, and cute. Two years later, we were married. At our rehearsal dinner, my mother toasted us and hoped that our dinner conversations would involve more than dissecting the rubrics of the *Book of Common Prayer*. And yes, they do, in case you were wondering.

But Adam is not my dad or my grandfather. And our love story is only twenty years in the making. Lots of love still to be made, and cherished. Sometimes I am not sure Adam knew what he got into. I just don't make those gushy posts on Facebook— "You are my whole world"; "You are my rock"; "You are my everything." No, I keep everything pretty tight, because what if he just dies and leaves me as well?

Most middle-aged men have developed a dad bod. But when my own husband jokes about his secret stash of Doritos, or my kids reach out to smush his belly, I feel it like a personal attack on the longevity of our marriage. I vacillate between anger and fear because I do want him around for the long haul. My fear is that he

will suffer a heart attack and die. And then I am afraid I will be so mad at him for dying, but because he will already be dead, he will be blissfully ignorant of this anger.

In preparation for my widowhood, I often remind him that he must walk me through all the remotes in the house. I pay attention to the refrigerator when it says it is time to change the filter, even though he usually does this task. I remind him to write down all our passwords, just in case. We both have mastery of all our financial accounts, so I am confident that managing our money will not be a problem. But when he is out of town, I practice being a widow. Can I reach that top shelf and get the toilet paper stored up there? Yes. But I have come to terms with the fact that I will have to give up composting. (I can never remember when the eggshells are allowed to be mixed with the vegetables.) And, truth be told, we both have had our funerals planned and our wills drawn up since our first child was born. As clergy, I suppose we are both prepared for death to some degree all the time.

Loving with deep abandon is hard. There is a running joke about country music. If you play a country song backwards, you get back your pickup truck, your cowboy boots, your religion, and most importantly, your man. I haven't lost my man, but sometimes I live my life playing, on repeat, the tragic version of that song in my head.

Reflection Questions

- What is your earliest memory of the loss of a close relative?

- Did you have an adult mentor who shaped, either for good or for ill, your worldview with regard to faith?

- Whether you are married or single, do you see ways God is still working in your life through your close relationships?

Grandfather Michael and
the Communion of Saints

After my Uncle Stephen's funeral and burial, to which Samuel proudly accompanied me, we gathered for a luncheon. He parked himself at a table amongst his first cousins once removed, and proudly declared, "You know, my mom's last name is Wilcox too!" (Yes, I am one of those women who kept her maiden name.) And without skipping a beat, my cousin's son replied, "We know! That is why you are here."

And that is why you are here. Yes, my father's brother died a few weeks ago and I traveled to Connecticut to be with the Wilcox side of my family. Sam's statement is most revealing in that he had never met any of the Wilcoxes, outside of our nuclear family. With my father dying at age thirty-four, and with me growing up without him, we were in touch with the Wilcoxes as children. But once the matriarch died, it was harder and harder to keep family gatherings a part of our regular routine. Combine this with the fact that we have many cousins, and we all moved to different parts of the country, got married, and incorporated those families into our lives, and we added children to this scenario. Well, I bet you know the drill; it is hard to coordinate large families.

So, Samuel's innocent discovery was a real one, perhaps a revelation. "I have a mother who is connected to all you people in some way." And, yes, the time with the Wilcoxes was a painful gift of remembering my heritage, and tracing the life of my beloved father, and mourning the loss of my uncle with his devoted wife and children. In those short days, Sam discovered he had a Grandfather Michael, whom he had never met. He finally put together that Grandfather Michael was Bibi's (my mother's) late husband. It was a time of recounting stories about my uncle, and hearing in those stories echoes of my father—and the boy and man he was.

I knew being a part of Uncle Stephen's funeral and burial would be important for me as a priest and a niece and as a goddaughter—a gift in some ways to the Wilcox family and a gift in some ways for my father. But I had no idea the degree to which the grief of forty years would burst forth out of my eyes and my throat as we watched my aunt bend down on her knee to put the ashes of her husband in the ground. Just five feet away sat my father's grave. Forty years of absence, forty years of longing, forty years of normalcy too. After all, I carried grief for someone whose face you can only conjure with the help of a photograph, whose voice you never knew but, you were told, sounded just like Uncle Stephen's, a story you could cling to, but never a story you could ever own. This was the kind of grief that spilled out that day as I accepted a tattered Kleenex from my cousin.

On top of that, I learned that there was a palpable grief that my uncle carried with him his whole life. He missed his little brother. In the last days of his life, he reported seeing his brother again and my uncle felt delighted to think of the two of them being reunited. After all those years, he still treasured a worn photograph of my father all dressed up in his clergy garb. My aunt told me Uncle Stephen kept that picture on his dresser so that he would see it every day.

As a priest, I must admit I remain unsure about what happens at the time of death. I know from my years of sitting at the bedside of a dying person that the body eventually gets cool. I have felt those hands lose their heat while leading prayers at the time of death. It's a strange feeling to hold the hand of one person as they are slipping away and another's hand as it sweats and shakes from grief and anxiety. I certainly know what the sounds of strained breathing are like. I know what bodies look like after the mortician has had a chance to inject them with chemicals and make them look like strained—and sanitized—versions of their former selves.

Each week, I lead my congregation in the Nicene Creed, in which we profess, "I believe in the resurrection and the life everlasting." But I wonder if the resurrection of the body will be a new, recreated individual body for me—one without thyroid disease

and stretch marks. Or do we mean the resurrection of the body in the sense of the whole body of Christ—not individuals, but the corporate sinew upon the bones of Christ? I know the apostle Paul promises that we will all be raised together with the sounding of a trumpet. Paul's vision emphasizes this moment as a corporate event, as if we are in some kind of holding tank until Christ comes again and then we will all be raised in unison. Paul explains the mystery of the resurrection thus:

> Listen, I will tell you a mystery! We will not all die, but we will all be changed, in a moment, in the twinkling of an eye, at the last trumpet. For the trumpet will sound, and the dead will be raised imperishable, and we will be changed. For this perishable body must put on imperishability, and this mortal body must put on immortality. When this perishable body puts on imperishability, and this mortal body puts on immortality, then the saying that is written will be fulfilled "Death has been swallowed up in victory." "Where, O death, is your victory? Where, O death, is your sting?" (1 Corinthians 15:53)

Now the Gospels, which of course Paul did not have access to, talk about the resurrection of the body and the empty tomb. Luke's Gospel goes as far as to say, "Today, you will be with me in Paradise." Jesus makes this bold statement to the thief hanging on the cross right next to him. In contrast to Paul, Jesus seems to be saying that after the body has breathed its last, the resurrection happens immediately. The Book of Common Prayer seems a bit conflicted about the theology of the afterlife. It warns in the Thirty-Nine Articles about the concept of purgatory. However, the prayer book clearly affirms praying for the dead and teaches the doctrine of the communion of saints. The communion of saints is this great corporate worship and witness to God; it is the knitting together of all the faithful departed, which is beyond this mortal life. Through that, we know we will be raised to the life everlasting, and we will share in the fellowship of the saints.

I don't know exactly how Michael and Stephen will be or have been reunited. I don't know how their ailments have been healed.

I don't know what they can, or will, share with each other. But I do know that the communion of saints is that beautiful community in which there is no more pain or sighing. And I do know that even at the grave we make our song, "Alleluia, Alleluia, Alleluia." God's love was manifest in the tale of these two brothers, Michael and Stephen. Their lives and witnesses are carried on in all of us—seven children and nineteen grandchildren for Stephen, and two children and twelve grandchildren for Michael.

Samuel learned an important thing that day: his mom is a Wilcox and she came from a father whose name was Michael, and he was Bibi's husband. And all of that is a gift, even though that gift is not without pain. And someday in this great communion of saints, beyond our understanding and our logic, Sam will greet his grandfather when he enters into the fullness of eternal life and he might say to him with the same triumphant grin, "You know, my mom is a Wilcox."

Reflection Questions

- In looking back at your own life, have you ever been surprised by unresolved grief at an unexpected moment? If yes, explain.

- How do you talk about death with your children, family, or close friends?

- What do you imagine the resurrection is like? What do you hope for in "eternal life"?

Ritual or Routine: Raising a Child
on the Spectrum in the Church

My son, Theo, age twelve, leaned over the dishwasher and called out to his dad, "Why aren't you voting for Bernie Sanders? He's the one who is going to make it possible for you to have enough money to save for college. I just read an article in *The Atlantic* that said the average American doesn't have four hundred bucks in a pinch. Bernie can change that."

My sweet Theodore, my son with an insatiable mind, hungry for data, reading voraciously, making cosmic connections and engaging adults. This is the same boy who becomes lost upstairs when sent up to brush his teeth, who only recently learned to tie his shoes, who drops copious amounts of food on the floor when eating and doesn't notice if his clothes are on backwards. It's the same boy who puzzles over one sheet of math, his mind wandering, unable to either concentrate or summon working memory for his times tables. One delicious, delightful, and disabled boy.

When we first brought concerns to our pediatrician, it was difficult to pinpoint what made Theo different. As a mother, I would point to my intuition but thankfully, because God gifted us with two more children, I could see by comparison that my concerns were justified. I saw right before me the difference between neurotypical children and those with special needs. After a run-around with a public school that was unwilling to even provide him with a quiet space to eat lunch, testing by a neuropsychologist confirmed three different diagnoses and we were able to move forward to address Theo's needs.

All parents worry about their children, and yet a parent of a special-needs child worries in a different way. (This worry is somewhat like having an illness, such as diabetes, that is always lurking, where blood sugar levels are tested religiously, and every once in

a while an imbalance means grabbing orange juice and a Snickers bar.) We know that our primary vocation is to love our kids and raise them to independence. But with a special-needs child, we know we can do the former; it's the latter that keeps us at the work of appointment scheduling, Legos social skills groups, and teacher conferences. We live in that liminal place of anticipatory grief—not sure that our child will go away to college, pass his driver's test, or leave the nest. And yet these American ideals live in our consciousness even before these babies have stopped breastfeeding.

As a Christian parent, I have framed the raising of my son and my other two children in light of God's goodness. This is not to say that I minimize the absolute frustration of the days when meltdowns were so bad that all the furniture was rearranged—or even damaged. Our mailbox was a reminder of a particular calamity, crushed with a bat that had been lying around in the front yard.

I have a vivid memory of a moment when all three children were in the tub, a spot where I could plop them to soothe them and contain them to one place, and I said out loud to my husband, "Does being a Christian matter when it comes to parenting?" I remember thinking I was so exhausted and didn't know why God hadn't given me the superpowers of equanimity and patience all the day long. My husband's wise answer was that in the short term, "No, being a Christian probably doesn't matter. I mean God is not like a vending machine that provides you with a virtue whenever you ask for it." However, he pointed out that our choices to raise the children by committing to worship and a church community could only foster a relationship with God and others. The practices of faith are just that—practices—so that we, as Christian parents, have to grow into our faith and model that so that our children will see the life of faith as an active, living pursuit.

Theo and his younger brother, Samuel, were sharing a room and a bunk bed. They are five years apart, so when we would say our prayers, I would climb up to the top bunk bed and push my back against the bedrail, so as not to wake Sam. We had recently received the reports from all of Theo's testing and wondered how,

and when, we would share the information with him. But that particular night the Holy Spirit opened a door for us both.

Theodore had had a tough day. He was taking standardized tests and perseverating about them and how they relate to his self-worth. He queried as I marched him to bed, "Mommy, am I smart or am I intelligent?" I told him he was both. And I knew from the recent evaluations that his verbal acuity is off the charts. He replied, "Well, sometimes I don't feel smart." This comment seemed to be the perfect opening

As he pulled his covers way up to his neck, I said to him, "We found out something today." I dove in. I brought up a teenage friend of ours in the church who has autism and I told him that the evaluation said he has autism, just like our friend. I delicately paused and Theodore replied, "Yeah, I surmised that when I was reading about autism one day on your computer. I've already embraced it." I started to weep and as I wiped snot from my face, he said, "I thought, based on the fact that my tic disorder and my ADD often go with people with autism, that this just completes the circuit." And, indeed, it completes the circuit on a child who is extremely perceptive, bright, and self-aware—unique attributes for autism—but who, at the same time, focuses narrowly on topics, can talk incessantly without picking up cues to have a two-way conversation, has difficulty reading body language, and can just get stuck. Yet, my Theodore never ceases to amaze me.

That conversation began an ongoing conversation. We honor Theodore's inevitable existential questions about why he was made this way. We have tried to explain that we all are made in the image of God, but because we live in a world that is not perfect, there are parts of us that don't work perfectly. And yet, we emphasize that all of us, including Mom and Dad and Brother and Sister, are working on something—as we strive to be imitators of Christ.

When I say "imitators of Christ," I am talking about sanctification. That is to say, life is a process of repentance. "Repentance" in the Greek just means to turn. So, as Christians, we are constantly trying to turn toward God. Practices of prayer, worship, and learning

about God all help us become imitators of Christ. However, let's be clear that none of us are meant to be the Messiah.

In support of this effort, I try to ground my children's identities in their baptisms, and ultimately, in the Christian faith and life. We do this specifically by celebrating the anniversaries of their baptisms. Some years it involves a baptism cake and phone calls from their godparents. Other years it is a mere mention at the end of the day when we say our prayers. For each of my children, I created a baptism box. Inside is the bulletin from their baptism, the cards people sent, real pictures of the day, and even the shell that was used to pour water over their heads. For me, baptism is a reminder that each child is connected in an indissoluble way to something greater than their imperfect parents and siblings. At baptism, godparents were chosen so that my children would truly know there is a great cloud of witnesses who love them and care for them. And we also pray for those godparents, each night, etching them with our breath as we say their names before the kids sleep.

Our children experience the church as a great source of strength and belonging for them. Both my husband and I are priests, so I have never done any intentional advocating on Theodore's behalf at church, like I have to at school. But I suspect that parishioners who are emotionally intelligent know there is something unorthodox about my boy. And despite some of his quirks, he is an excellent acolyte and leads a procession with precision, and delights in singing in the Men and Youth Choir. It also turns out that he has an amazing gift as a lector.

He needs his church, and his church needs him. For my son, the church is a place of peace and, more importantly, routine. We Anglicans call this "liturgy." While some may criticize our denomination for liturgical routines that might be seen as rote, my son Theo is freed by them. To our son, liturgy is dependable and a source of comfort in a world that can often feel like sensory overload.

Raising a child with special needs as a Christian may be a path peppered with more patience and ambiguity than parenting a neurotypical child. Sometimes when I hit that place that the psalmist describes where my tears soak my bed, I try to hold on

to this beautiful prayer that our whole congregation prays, as does every Episcopal church, when someone is newly baptized: "Give them an inquiring and discerning heart, the courage to will and to persevere, a spirit to know and to love God, and the gift of joy and wonder in all God's works."[1]

Reflection Questions

- Have you ever known someone well who is on the spectrum? If so, what did they teach you?

- What type of spiritual gifts do you think neurodivergent people bring to the church?

- What surprised you most in this piece? Why?

1. Episcopal Church, *The Book of Common Prayer and Administration of the Sacraments and Other Rites and Ceremonies of the Church: Together with the Psalter or Psalms of David According to the Use of the Episcopal Church* (New York: Seabury, 1979), 308.

Why Do People Keep Walking into My House?

There was a sense of relief as we handed the keys back to our parish administrator on the day of our move. While the house we had lived in had lots of charm, the location was a disaster. Our children picked up condoms in the snowbanks thinking they were balloons, people screamed every morning at 6 a.m. across the parking lot, and car doors slammed as nursing home staff changed shifts from the dilapidated state-owned facility across the street. Preschool parents walked into my kitchen looking for their children, even though there was a big sign on the door stating, "Private Residence." The first time this happened, I was terribly offended. Then I looked around my kitchen and noticed cubbies, children's artwork hanging from a clothespin, and shoes strewn all over the floor. Maybe the constant frustration of feeling on display had made me overly sensitive.

Our house had no private entrances. The front door was accessed from the church's sidewalk. To bring groceries in the back door required breaching a chain-link fence and climbing over sundry plastic toys and actual preschoolers. If we chose to grill out of our back door, the preschool children gathered to watch and often queried, "What are you having for dinner?" as they pushed their hands and noses through the openings in the fence. I'll never forget the day I was a prisoner in my own car because I had just gone to Victoria's Secret to buy new underwear. A gaggle of parishioners stood outside our front door, and I had no way of getting in the house without parading my bright pink bag in front of them. I'm an Anglican, not a Puritan, but it still felt awkward.

I was eager to leave that living situation behind. What a relief and, literally, a breath of fresh air when we moved to our own home. We have discovered the joys of living in a neighborhood

where bikes zip down alleys and children ring doorbells asking for playmates. We are learning the challenges of home ownership as we clip down overgrown raspberry bushes, weed unkempt gardens, have ceiling fans replaced, hang pictures, and find project after project to prioritize. We are beginning to know where to find fresh eggs and access the local Target. This process is all mapping and orienting in a new environment.

Every time we move, I feel a sense of confusion. I know that I will eventually be inside a Target—and because the stocked shelves and red bullseye feel so familiar, I will not be sure which town the Target is actually located in. There is no denying that several mornings after we moved I awoke completely disoriented. Why was it so quiet? Where was I? After a few moments, I realized I was in our new home. No more cars careening into our church parking lot next to our bedrooms. Now all I hear is silence punctuated by birds' chatter.

In that silence I remember all of our anxiety before we announced our move to our children. We knew such news would be most challenging for our oldest. He likes routine and the three-story Victorian rectory we called home. His initial response involved much resistance and focused on persuading us to postpone the move until everyone was older! Later, he even accused me of calling the new place a utopia.

Our nine-year-old daughter, when told we had big news, piped up and said, "Are we moving?" And, yes, our family spy had figured out there were muted conversations and closed doors afloat in our house. While initially putting on a happy face, she later looked out her bedroom window, which faced the slate roof of the church, and lamented that she would never be Mary in the Christmas pageant.

And our six-year-old boy handled things very directly by bursting into tears. As we comforted him, we quickly learned the tears were not about the move, but about thinking that all the valentine cards he had made were going to go to waste. Once we explained we weren't moving for a few months, and the valentines

would go in the brown paper bags at school, he calmed down and moved on.

I can't help but wonder how I, as a Christian, might best view the modern-day phenomena of moving. We know that moving is often necessary in order to find meaningful work. In a clergy family it is just a way of life. And it's part of Scripture too. The Old Testament biblical witness is focused on finding the promised land. As the Israelites wandered in the desert longing for home, they found it easy to complain about missing the leeks and honey back in Egypt. But as the story of Scripture progresses, the sense of what the promised land means continues to change. Sometimes it is one specific place; sometimes it is the holy of holies (the arc of the covenant) moving from place to place. Later, it is the temple itself. Clearly, home continues to be defined and redefined.

In the Gospels, Jesus is born into a specific town and community, which is later held against him. (After all, can any good thing come out of Nazareth?) But even at the age of twelve, Jesus assumes the role of teacher in his faith community. His parents leave the temple without knowing they have left him behind interpreting the scrolls. This event foreshadows his life as he becomes an itinerant preacher throughout Galilee.

John's Gospel talks about his Father's house in which there are many rooms—or, as some translations say, many "dwelling places." This passage is often read at funerals. I can't help but think that a move has some parallels to death: we learn to detach from our stuff, favorite coffee shops, walking our kids to school, and, sadly, even from our friends. And yet, the good news is that all of life is detaching from that which does not last forever and clinging to the good news in Christ. That good news is that we do not need to live in fear, that Christ accompanies us on this move, and that those whom we love will join us fully in that great party of the eucharistic feast. Someday, all of our moves will be rolled into one. And that new home will be a place where there will be life everlasting.

In the meantime, now that we have moved, everyone asks, "How are you settling in?" As I reflect on those words, I think they are apt. Life was turned upside down and now it is time to

settle in. With one child on the spectrum, I was very fearful of the change. How would he adapt to the loss of his Legos social skills group, his sweet friends, and his tiny, independent school? Yet I have been amazed that he has embraced his new room and his new school in stride. My daughter appears to let everything roll off her back and has already managed to secure phone numbers from other parents to arrange playdates. But it is our seven-year-old, the one who had seemed most blasé about the move, who cannot fall asleep at night. For one, he is in a room by himself for the first time. He reports scary faces and noises. Every night we find him sprawled horizontally against our bodies—or holding his sister in a sweet embrace in her single bed. He can't even seem to self-soothe anymore. And I wonder about rituals and settling in and helping him find a way to fall asleep here.

I know my sleepless nights involve the task of finding friends *again*, at the age of forty-five. Deep in my heart, I know that I have mastered the skill of long-distance friendship—and this was even before I discovered Zoom. Friends from college, Tanzania, seminary, Chicago, Madison, Media. And now Carlisle, I hope. But it's much easier to make a friend on a playground bonding over napping challenges than when kids are old enough to choose their own friends. Throw in the whole, "I'm a priest, but I'm also a normal person," and pursuing friendships in late middle age is wearisome. And when people I meet say, "Oh, you are a pastor," I must explain, "No, I'm an Episcopal priest." Inevitably the response is an awkward pause, sometimes followed by, "I'm spiritual, but not religious." It's hard to navigate explaining your vocation in each new zip code.

I wonder at each move how I will summon the energy to do the moving thing again. And yet, I know we will have to move at least one more time. It is the custom of the Episcopal Church that you do not retire in the same town where you have served a parish. While that makes complete sense, it is exhausting to know that as you unpack the silverware you will be packing it up again in x number of years.

In an attempt to provide some comfort to our whole family when we departed from our last home, we took a bowl of water and a turkey basting tool and each child said a prayer and sprinkled, or doused, a room with water. We thanked God for each room and its purpose for us. We remembered funny stories and brought them up as we said goodbye to that space. I have no idea whether that made our move smoother. As my husband, the social scientist, would say, we have no counterfactual—no other way to measure that. But a small part of me thinks that the liturgical action of blessing and acknowledging the presence of God in that place may have paved the way for them to settle into this new place. I am not convinced it was providential, but I am thoroughly convinced that grace abounds. And in ritual and in prayer, by pausing and glimpsing the past, we name and see grace. Taking the time to gather as a family and bless our house, amidst the torn cardboard boxes, signaled that surely the Lord was in that place.

Fast-forward to the house we purchased in Carlisle. There is a white sign in front of our new house that states, "Church House established 2005." (That was the year the church, which was formerly Pentecostal and then a Christian Science meeting room, was flipped to a house.) Yes, the clergy couple who vowed they would never live in a rectory again ended up buying a house that was once a church. As we settle into the "Church House" we will paint, arrange and rearrange furniture, settle into the silence, and make our church house a home.

And home is complicated for me. As an itinerant preacher married to another itinerant preacher, some nights we stay up late in bed, after we have said our prayers, and fantasize about retirement. Even though we have at least two decades to go before we find a permanent home, our hearts are always longing to find the promised land, our final resting place. Until then, we continue to live by the adage from Saint Augustine's *Confessions* that our hearts are restless until they rest in God. Restlessness is that desire to be filled and fulfilled. We all have it. We try to ignore it at times, but still it remains. The day our family created a new ritual in our Victorian rectory with a turkey baster and water, we

were reminded that God is found in the past, the present, and somehow, I trust, the future.

Reflection Questions

- Have you ever had to move? If so, how did it change your life? If you have not moved, do you ever wonder what would change in your life if you had to move?

- Do you think moving should be a Christian discipline? Why or why not?

- What kind of ritual might you create to help you or your family in the process of a move?

"I Will, with God's Help": Baptism, Death, and Grandma AD

As a family gathers around the baptismal font, the words asked of the godparents are some of the most poignant queries. "Will you be responsible for seeing that the child you present is brought up in the Christian faith and life?" "I will, with God's help," the godparent responds.

"Will you, by your prayers and witness, help this child to grow into the full stature of Christ?" Again, "I will with God's help." But what happens when the child is not yet grown and his godparent dies?

The day we stood huddled at the font at the Episcopal Campus Center, St. Francis House, in Madison, Wisconsin, our son was about five months old. Godparents gathered, even from across the pond, and promised to raise him in the Christian faith and life. One of his godparents was a local friend named Susan, whom I had met through my work as the chaplain for the Episcopal campus ministry. Susan had been a part of St. Francis House thirty years ago as a student and had continued to be a positive source of energy for the campus ministry when I was chaplain. She was an ordained deacon in the diocese as well. We hit it off and became not only friends, but sources of spiritual support in our respective ministries. I could not think of a more qualified and apt choice for godmother.

We no longer lived in the same town, but I knew Susan had been sick with early-onset dementia for some time—making communicating with her long distance challenging in the very least. But while traveling in England we learned that Elias's godmother had been placed in hospice care, and my mind began racing through our track of memories. I kept imagining Susan, hopefully resting comfortably, surrounded by the people she loved, getting ready to

end her earthly journey. I checked my email whenever we had wi-fi, expecting to hear "the news." When it finally came two whole weeks later, we were ready to board our flight back home.

How do you grieve someone you haven't seen consistently in the last eight years?

How do you grieve someone whom nobody in your current town knows? And how do you help your child grieve for a loss he can't entirely comprehend?

You reach out and call a friend you had in common back in the day when the children were born. When Susan discovered that Kelly and I would be in the same birthing class, she rejoiced and connected us. It was Susan who encouraged our friendship by being the first person we made a coffee date with when the boys were three weeks old. I clearly remember trying to get my boy fed and dressed and out the door with dry pants. By the end of our coffee date, he had peed on Susan's jeans and she laughed and made one of her wonderful quips. Susan remained a friend of both of ours the whole seven years we lived in Madison.

Susan sat on my weathered blue couch and held me after not one, but two miscarriages. She rejoiced at the birth of my first child and accepted the duties of godmother with such joy. She became known as "Grandma AD," which was shorthand for Grandmother Archdeacon. You see, Susan was big stuff, but she would never tell you that. She had a background in languages and education. And later in life she was ordained an Episcopal deacon, serving the church with faithfulness and an ebullient personality. Her gifts as a listener and as a communicator served the church so well that she was named an archdeacon in the diocese.

Susan and I spent many a day riding in her red Volkswagen with the "GODSPEED" vanity license plate. We talked theology, politics, child-rearing, and life. Susan had an infectious laugh and energy. She embraced me as a new mom and loved me through the ups and downs of breastfeeding, sleep patterns, and introducing solid foods. I have many memories of us walking through Wingra Park with the stroller and stopping at Michael's Frozen Custard on the walk home.

So many memories, and yet my own son, Susan's godson, could barely remember her.

So, we pulled out an old picture album—yes, before all pictures were digital—and we talked about each one. We then made an impromptu spot on our bookshelf to display Susan's pictures. We gathered before dinner and held hands and prayed for Susan. I continued to cry from time to time, throughout the week, and my now newly minted thirteen-year-old would say to me, "It's OK, Mom. We will get through this together."

I realized my grief was not his. Susan's voice was still so clear in my head, but he had a hard time even recalling what she looked like. But helping him have some kind of process to grieve the loss of his godmother was important. This year, my church will offer an All Souls' liturgy for all the faithful departed. I will bring my pictures of Susan and place them alongside those of all the faithful departed. I will imagine her exclaiming at the end of the liturgy, like any good deacon, "Go in peace to love and serve the Lord." To my dear Grandma AD, I will muster the response, "I will, with God's help."

Reflection Questions

- How do you grieve someone you haven't seen consistently in a long time?

- Have you ever had to help a child grieve a loss he or she can't entirely comprehend?

- If you have lost a loved one to dementia, what do you wish they had known before their illness progressed?

The Pandemic and the Priesthood

M y birthday was two days away when the call came that the schools would be closed for two weeks. We scurried around our office and ran into the church to be sure that all the lights had been turned off and candles had been blown out. Standing there bathed in light from the stained glass, I imagined I would be back very soon and didn't think to bid the chapel adieu. I grabbed my prayer book, Bible, and a few folders, locked my office door, and headed home. We had just heard that the Episcopal church in Georgetown had become ground zero for COVID. Both the rector and the organist had contracted the virus. I remember earlier that morning throwing the *New York Times* at my husband in exasperation and begging him to shut down church for the coming Sunday. "What if some elderly parishioner dies because we gave her COVID from the chalice?" The diocese had not yet sent a directive. However, in this instance, the Carlisle School District saved us, for the parish policy was that when schools closed, so did we.

Looking back at that moment, I know we knew so little. I am not usually an anxious person when it comes to germs. I wash my hands, just like the rest of you. But I have never carried hand sanitizer in a purse. When I lived in Tanzania, my mosquito net protected me from bugs and creepy creatures. But it didn't keep me from contracting schistosomiasis or sharing sleeping space with a severed cow's head. I have always kept the parenting philosophy that getting dirty is part of a child's work and that a good bath cures most ailments. Who knew that it would become common practice for priests and deacons, as we set the table for Eucharist, to not only do ritual washing with the lavabo, but also to slather our hands in sanitizer?

My parish directory became a lifeline during those first few weeks, and later months, of quarantine. I started with the back. As a Wilcox, I always felt like the end of the alphabet got the short end

of the stick. I started calling everyone I knew who lived alone. After about three or four calls, I would sit on my plain blue Ikea couch and stare into space. I don't think you could call my daydreaming "prayer." I would pray, though, as I went for one of my many daily walks. And every night I would reach for my husband's hand, pull it out from under the covers, and we would pray. First we prayed for testing, and then we prayed for those who got COVID, and then we lamented and cried for those who died of COVID. Later, we would bargain with God and say, "Why won't you let us at least gather outside to bury the dead?"

And our beloved parishioners did die, with iPhones cradled at their bedsides. Visits on front porches and chalk drawings in folks' driveways were new forms of pastoral care. Later in the pandemic, we gathered, completely masked, in a full circle administering last rites. We even held hands because, by then, we knew COVID isn't transmitted by touch. One sacred moment was followed by an email telling me that one of the folks in that circle had tested positive for COVID. I started to monitor myself for symptoms. Was it worth risking this mysterious, sly, and potentially deadly illness to care for others at their moment of death? I mean, I could be the hero, but what if COVID wreaked havoc on my own autoimmune disorder?

And while I worried about those who lived alone, I was surrounded by four other people and felt a level of loneliness that I could not recall having felt before. We didn't "pod" with anybody else, as we had only moved to this town two years before the pandemic and were technically still new. We spent a lot of time with our children trying to manage their fears and their online schooling. One child dove deeply into Rubik's Cubes and was obsessed about making solves. Eventually he refused to go outdoors. The virus changed his temperament. Our middle child, in early adolescence, lost all physical contact with her friends. Sadly, COVID forced Facetime to become her best friend. And our oldest paced around the house in circles; "peripatetic," I guess, is the technical term. Once he was done pacing, he would write—his creative outlet and release. And my husband would work in the

kitchen, at a standing desk, or in our bedroom leading evening prayer, or on Zoom in our courtyard holding finance meetings. I never knew when we would be shushed because he was leading a meeting, while the rest of us were just trying to assemble a turkey sandwich for lunch.

Once we figured out how to film liturgies, that day was our "big" day out. On that one day, life almost felt familiar. We would shower and put on a black clergy shirt, button the back of the clerical collar, and head into work. Lest I got lulled into thinking this was really a "normal" day, I would find the sacristy freezing cold. After all, why heat a section of the building that remains empty for the whole week? Fumbling for working batteries for my microphone, I'd then slide on my black cassock and that was another concrete reminder that the church was not together. Morning Prayer instead of Holy Eucharist, our communal meal. As I finished adjusting my mask, the quiet enveloped me and I ran through a list of questions in my mind. What color stole today? Did someone light the candles? Will our Scripture reader show up? Is the recording equipment software on the fritz today? Did we get the volume fixed on the microphones? Will I trip over the wire that has been laid in front of the organ pipes so that people can actually hear our organists' hard work and offerings to God? Oh, and who is going to run the lights for the sermon? Most days of filming started with hope, but inevitably there would be some kind of blooper, as we clergy became actors, choreographers, and script writers—skill sets that were never developed during our seminary training.

Our diocese was not yet allowing us to gather in person, so we were grieving the loss of the Holy Eucharist. On Facebook, everyone had become an armchair epidemiologist. And we as clergy were trying to combine epidemiology with theology. Throw in a dash of live-stream technology and you might be able to envision some of the quandaries. Some colleagues argued the Eucharist is so important that people should get it by any means necessary. Drive-by Communion, like Uber Eats, became a thing.

But if the Eucharist is truly a meal of the community gathered, and the community couldn't gather, how could we take, bless, break, and give this holy food? One of the hallmarks from the Anglican Reformation is that a priest does not celebrate the Eucharist by himself. The Sursum Corda, "The Lord be with you" and the response "And also with you," is an invitation into dialogue in the faith community, not only acknowledging, but insisting, that priest and community cannot be separated.

And yet another fruit of Reformation-era theology is this idea that when the faithful lift up their hands to receive the host, they become a part of that bread, truly becoming Christ's body—"real presence" as it came to be known. The actual eating of the sacrament of the faithful is, indeed, part of the consecration. It was hard to justify a grab-and-go theology. So, we fasted from this holy meal for some time. A long time, really. We waited with great anticipation for the positivity rates in our community to go below 5 percent because then the diocese would allow us to resume corporate worship.

During that time, which ended up being five months, on the second round of lockdown, I tried to exercise every creative bone in my body and still felt like I was staring into an abyss. Some parishioners wanted connection and we responded. We would set up small groups on Zoom to meet their needs and then the next week those same folks would not show up in the Zoom meeting room. We created a beautiful outdoor Easter liturgy because the diocese wouldn't let us gather in person just yet. There was incense, acolytes, a world-renowned soloist, altar flowers, and even bagpipes. Some boycotted because they wanted to have Easter inside the church. Somehow, I think they forgot that even Jesus didn't celebrate Easter in the church. Resurrection was an empty tomb after all.

I remember sitting in my bedroom and staring at the wall as depression seeped into my mind and body. While everyone was busy making sourdough starters, I had to push food away because of my thyroid disorder. While my children baked every cake and cookie on the internet, I smiled and starved. I contemplated calling an in-patient facility and before I even googled it, I laughed. Would

you dare leave the house to get treated for depression? And where in the world had open beds for depression like mine? I mean, I hadn't tried to kill myself or anything. I was just depressed. Lonely, tired, and teary. I told my husband I was going to hang up the stole. And he looked at me with bewilderment and said, "So what would you do for a living?" I pushed back and said, "I always thought I would make a decent teacher" Before I had time to pull those words back into my mouth, my husband looked at me and we both smiled—recognizing the idiocy of my statement.

So many of us—theologians, clergy, and laypeople—tried to make sense of the pandemic theologically. Those who know me well know that I absolutely hate the phrase "Everything happens for a reason." We all want to make sense and meaning out of this world we live in. But if we do it with bad theology, we have not just misread and misunderstood the gospel, but we have done a disservice to the faith. In the case of a global pandemic, bad theology can be the door to death. As we all know, early on in the pandemic some clergy said that God would protect the faithful from COVID. We know that to be resoundingly false. It's that stark.

When I returned to my weathered and cheap Ikea couch, I found myself coming back to this question: Do we love God because of what we have received, or because God is God and loves us first?

As a preacher and a teacher, I love to point people to the Psalms, where God's people cry out and rail against God. Or I remind them of Jesus' closest friends—Mary, Martha, and Lazarus—in John's Gospel when Mary says, "Lord, if you had been there my brother would not have died" While technically Mary may be making a statement, she is also framing a lament. Our God, in Jesus Christ, does not shy away from the hard and difficult questions. Jesus even cries out to God the Father, "My God, my God, why have you forsaken me?" Our God is one who has gone to the depths for us, who knows the pain and tragedy of a man like Job. Our God is a God who can handle our questions when we get diagnosed with stage-four cancer at age thirty-four. Instead of answering, "Everything happens for a reason," our God

will dwell with us in the mystery, and love us, while we exist as fallible vessels in God's creation.

In my heart and soul and mind, I love being a priest. With perspective, I can see that the emptiness of the pandemic was not a measure of whether God loved me or not. In a way, I was putting the Lord God to the test by thinking that I had to feel God's presence in order to know that God still dwelt with us. I sure had my wilderness time on the worn blue Ikea couch. I sure had my moments of frustration on film and as a beleaguered mother and spouse. But as I look back, the grace in the rearview mirror is this:

I refuse to romanticize the COVID era, but I did learn that it is absolutely permissible, if not imperative, to pray as I can and not as I can't. Even St. Paul assures us, "Likewise the Spirit helps us in our weakness, for we do not know how to pray as we ought, but that very Spirit intercedes with groanings too deep for words" (Romans 8:26). Perhaps Paul uses the word "groaning" with intention. Sometimes our prayers are indecipherable, but they are still considered prayers.

The pandemic fostered constant conversation with God and now, looking back, I can see that the grace in those isolated days was that God and I continued to converse. I wish I knew at that time that even my groanings were an offering to God. May I always be reminded that our prayers and our lives should be closely aligned. May God grant me the courage to now live the words that I have prayed. And may God please keep me close, so that I can decipher the indecipherable.

Reflection Questions

- Did you experience a crisis of faith during COVID? If so, explain.

- Do we love God because of what God has given us?

- What would you name as your grace in the rearview mirror when you reflect on your COVID experience?

Chapter 5

Instructions for Writing and Sharing Your Spiritual Autobiography

While most of us have never written our autobiography, we know what one is. It usually covers the events of your life. Typically, autobiographies focus on the events that might seem most interesting to the readers. A spiritual autobiography, on the other hand, is written primarily for yourself. It's an opportunity to examine the events of your life from a different perspective. You don't necessarily focus on what might be most interesting to the observer. You don't even focus on the milestones of your life. Instead, you consider the moments when you felt God's presence in your life. It might be a small moment, like when you heard a hymn and the words took your breath away. Or it could be a bigger moment, like the birth of your child. It could be anything. No moment is too small if it allowed for an encounter with the Divine. To help you create your own spiritual autobiography, we have provided a step-by-step guide that one of our authors has used for many years. There are also some additional questions that might stimulate unique insights.

A spiritual autobiography could be something you write for yourself, or something that you share with one or two other people. It could even be used in a group setting. While sharing a spiritual autobiography requires a degree of vulnerability, it can also be a transformative experience for a group. The authors of this book shared their spiritual autobiographies at a retreat they attended. While their small colleague group had been meeting

for almost a year online, this was the first time they had met in person. In telling their stories, they found connections with one another that they had not yet discovered. Sharing a spiritual autobiography with a small group can also provide opportunities to see new things in your story. Often when we share our story with others, we gain new perspectives. We can also learn a tremendous amount by hearing the stories of others. Even though our biblical canon is closed, we believe the story of God's ongoing revelation continues. All of our stories are just as sacred, and just as important, as those included in the Bible.

Instructions for Writing and Sharing Your Spiritual Autobiography with a Small Group

1. Each person is given a large sheet of paper, a poster board, or newsprint, as well as a handful of colorful markers.

2. The facilitator of the exercise invites participants to create a timeline of their lives, starting on the left side of the paper and moving toward the right, with the line going up to illustrate high points, and with the line going down to illustrate low points. People may use their pens to write words, doodles, and pictures to illustrate what was happening at certain key points in their lives. The facilitator makes it clear beforehand that people are invited to do their own personal reflection, which they can choose to keep to themselves or share with the group. A person is more than welcome to deviate from the instructions if the Spirit moves them.

3. People are invited to spend some time working silently on their individual posters. This could take twenty minutes or more depending on how much time you have.

4. The facilitator regathers the group and invites people to volunteer when they are ready to share their timelines. Each person is given a set amount of time to share, perhaps five to eight minutes per person depending on how much time

you have together. Consider having someone serve as a timekeeper.

5. When it is a person's turn, they show the group their timeline while talking about what was happening in their lives during the high points, the low points, the bumpy times, and the moments when they felt God's presence. The facilitator should invite group members to respond with phrases like "Thank you," "Wow," and "I really appreciate what you shared." In general, the sharing will go better if people only express affirmations and appreciations, rather than asking probing questions or pointing out what they noticed. This boundary-setting is important to do prior to the sharing time.

6. After everyone has had a turn to share, the facilitator invites group members to pray together, giving thanks to God for the blessings and challenges in their lives.

7. In the closing comments, it's always good to point out that sometimes the fruit grows in the valleys, and not on the mountaintops, even though mountaintop experiences can be rich. The group might reflect together about whether this seems true in each person's experience.

Acknowledgements

This group of women would not have come together had it not been for a program called Thriving in Ministry, which is sponsored by Virginia Theological Seminary and the Lilly Foundation. The authors are grateful for the initiative and support of Thriving, including the leadership of Carol Pinkham Oak and the mentors who led their group, Mark Stanley and Mary Luck Stanley. During the writing and editing process, the group received assistance and support from Laura Oliver, who is the author of *The Story Within: New Insights and Inspiration for Writers.*
—Kelly, Mary, Samantha, and Melissa

I would like to thank Gar, Riley, and Asher for their patience and support as Mom figures out this writing stuff. I thank my mom and dad for their encouragement and my grandmothers, Mary Jane and Rosemary for giving me a love of the written word. —Kelly

I will forever be grateful to Amy Richter, Laura Oliver, and my colleagues for welcoming me into their writing group and encouraging me to write. One of the main ways God has ministered to me is through my tribe in the Episcopal Church, and especially through my mentors, friends, and family, for whom I give thanks—Kitty Lehman, Amy Maceo, Julie Graham, Tom Skillings, Jennifer Baskerville-Burrows, Jess Sexton, Suzanne Popa, Thomas Luck, Jane Luck, Diana Luck, George E. Luck Jr., Jane Marti Luck, John Stanley, Lynne Stanley, and Mark, Jack, and Hannah Stanley. It's been a joy writing this book with my faithful, creative, and graceful coauthors! —Mary

I give thanks for my husband, Conor, who has always supported my writing and given me time and space to pursue my dreams. I am eternally grateful to my parents, who have read every sermon I have ever written and every essay I have sent their way. They remain my greatest fans and I theirs. My son continues to inspire me, make me laugh, and open my eyes in ways I never thought were possible. I am also grateful to the people of St. John's Episcopal Church, who provided me with a sabbatical and the financial support that enabled me to dream and write. They have made me a better priest. Thank you also to friends and family who have read my writing and been relentlessly supportive, especially Elizabeth Felicetti and Elise Myers. Thank you to this group of women clergy and friends who accompanied me on this journey. We did it! Most importantly, to God, who is the source of all grace I have experienced in my life. —Samantha

Without the work of Thriving in Ministry, this book would not have come to fruition. I am grateful to our clergy couples group for our monthly Zoom meetings, but most importantly for the trust and collegiality you have provided over the most challenging years of my ministry. To my fellow writers, I thank you for trusting the process and believing in each and every one of us. I still can't believe that we made this idea into a book. To my church, St. John's, for sharing your lives and stories with me—what a privilege to serve you. To my brother, who set an example as a published author and offered his wisdom through the process. To my mom, who fostered my faith and always encouraged not only my writing, but me! And, of course, thanks be to God in Christ, whose power working in us can do infinitely more than we can ask or imagine. —Melissa

Made in the USA
Coppell, TX
16 May 2023

16934293R00079